Painting Figures

IN WATERCOLOR

Library of Congress Cataloging-in-Publication Data

Cuevas, David Sanmiguel.
 [Figura a la acuarela. English]
 Painting figures in watercolor / David Sanmiguel Cuevas.
 p. cm. — (Easy painting & drawing)
 ISBN 0-8120-9747-5
 1. Human figure in art. 2. Watercolor painting—Technique.
I. Title. II. Series: Easy painting and drawing.
ND2190.C8413 1996
751.42'242—dc20 96-14715
 CIP

Printed in Spain
9 8 7 6 5 4 3 2 1

IN WATERCOLOR

Painting Figures

BARRON'S

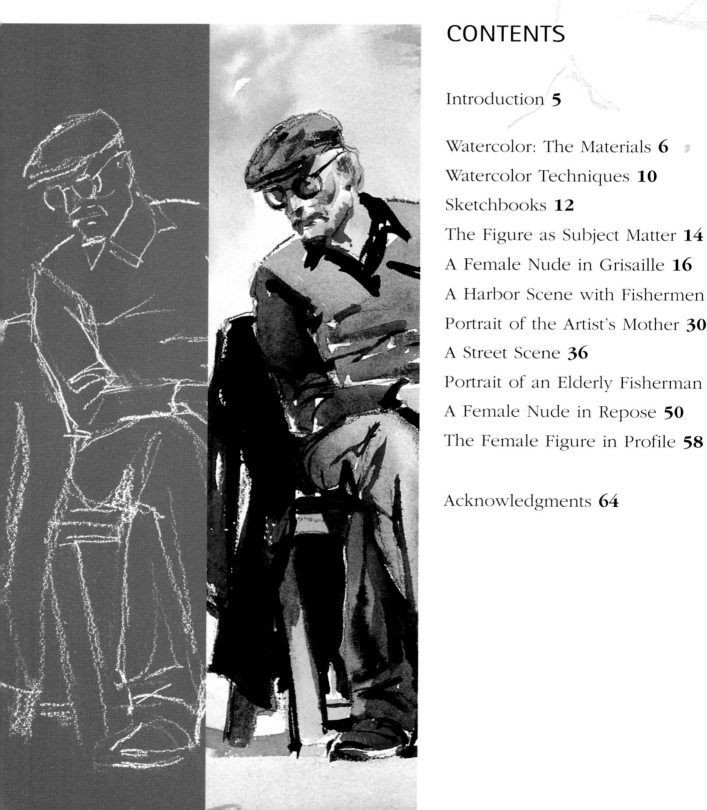

CONTENTS

Throughout the history of art, the depiction of the human figure has been a universal and frequently recurring subject. The figure can be found in bas relief and in mosaics, as well as in painting.

What makes the human figure such a popular subject is the seemingly infinite number of possibilities and wide range of interpretations from which the artist is able to choose. In addition to color, balance, composition, light, and shadow, we can add other aspects of a different nature, though no less important, such as dramatic effects, liveliness, or tranquillity. Thus, when the artist paints a figure, he or she is not only representing a person but creating a world of feelings—romance, tragedy, sensuality, sublimation, decadence, idealism, sadness, and so on.

With this in mind, we should try to combine esthetics and emotion if we are to attain the desired result that we set out to achieve. Painting a figure is not only a matter of combining colors, balancing form and volume, or resolving problems of lighting, but it should evoke some emotional response in the viewer. For this reason, the artist must be painstaking with the picture in order to express the sensation he or she wants to transmit.

This book has been written to introduce these questions and to enable you to discover the thousand and one possibilities that this subject encompasses.

The medium chosen—watercolor—is a difficult one to use. Spontaneity, freshness, and immediacy are elements that suggest speed, forcefulness, and ease. However, the looseness and apparent ease of watercolor are mastered only with much practice and trial and error, in order to overcome the numerous problems. Nonetheless, a brief examination of the results published here will whet your appetite to try your own hand at the fascinating subject of the human figure.

Time and patience are on your side.

Jordi Vigué

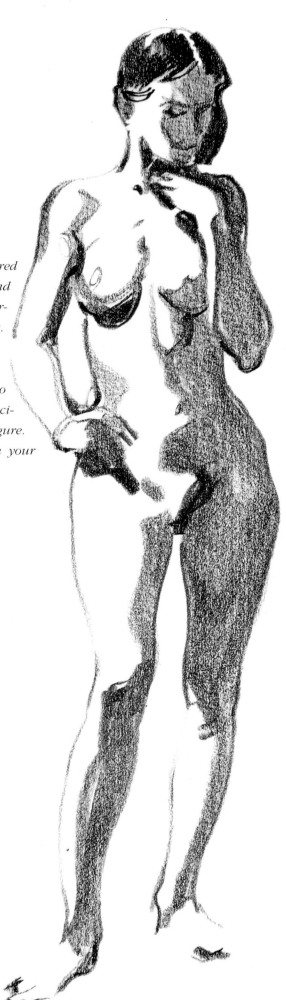

WATERCOLOR: THE MATERIALS

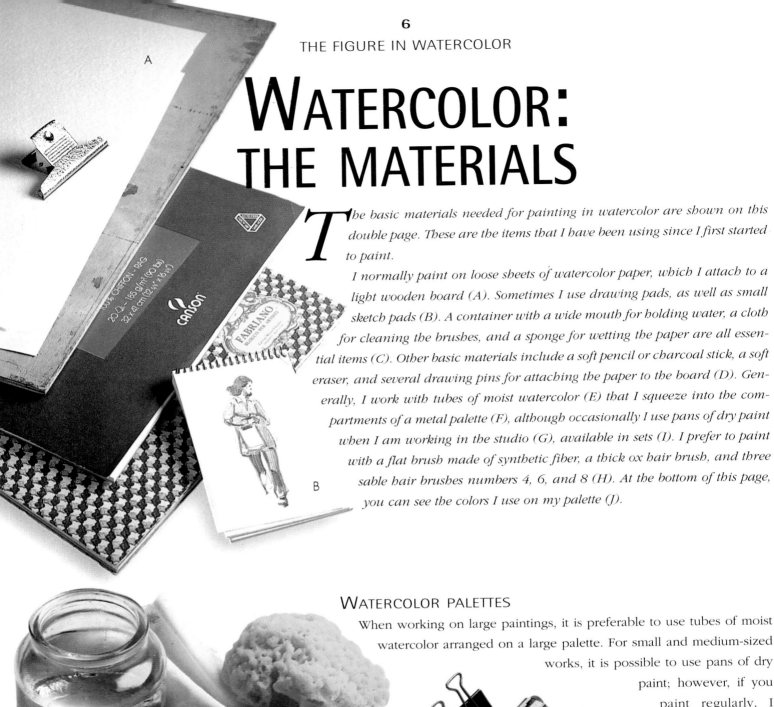

*T*he basic materials needed for painting in watercolor are shown on this double page. These are the items that I have been using since I first started to paint.

I normally paint on loose sheets of watercolor paper, which I attach to a light wooden board (A). Sometimes I use drawing pads, as well as small sketch pads (B). A container with a wide mouth for holding water, a cloth for cleaning the brushes, and a sponge for wetting the paper are all essential items (C). Other basic materials include a soft pencil or charcoal stick, a soft eraser, and several drawing pins for attaching the paper to the board (D). Generally, I work with tubes of moist watercolor (E) that I squeeze into the compartments of a metal palette (F), although occasionally I use pans of dry paint when I am working in the studio (G), available in sets (I). I prefer to paint with a flat brush made of synthetic fiber, a thick ox hair brush, and three sable hair brushes numbers 4, 6, and 8 (H). At the bottom of this page, you can see the colors I use on my palette (J).

WATERCOLOR PALETTES

When working on large paintings, it is preferable to use tubes of moist watercolor arranged on a large palette. For small and medium-sized works, it is possible to use pans of dry paint; however, if you paint regularly, I would recommend that you use a palette and tubes of color for all sizes of paper.

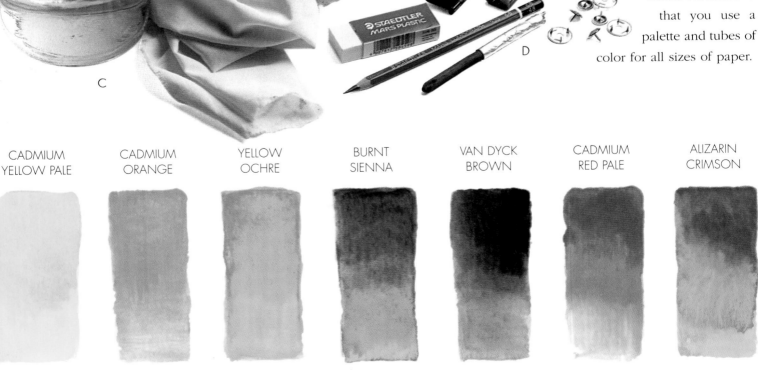

CADMIUM YELLOW PALE	CADMIUM ORANGE	YELLOW OCHRE	BURNT SIENNA	VAN DYCK BROWN	CADMIUM RED PALE	ALIZARIN CRIMSON

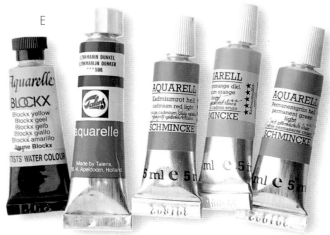

E

BRUSHES

The finest watercolor brushes are made of kolinsky sable hair. These brushes are very expensive, but if you look after them properly, they will maintain their shape longer than any other type of brush. There are also brushes made of ox hair (softer and very useful as round brushes in large sizes) and Japanese deer hair brushes. Synthetic fiber brushes, which are less expensive, are very efficient as flat brushes.

PAPER

The characteristics of the paper should depend on the type of picture you want to paint. There is a wide range of prices, thickness, and textures to choose from. As with everything else, the better the quality of the paper, the more expensive it will be. Our advice is to use 140 lb. cold-pressed water-color paper in single sheets or in a watercolor block.

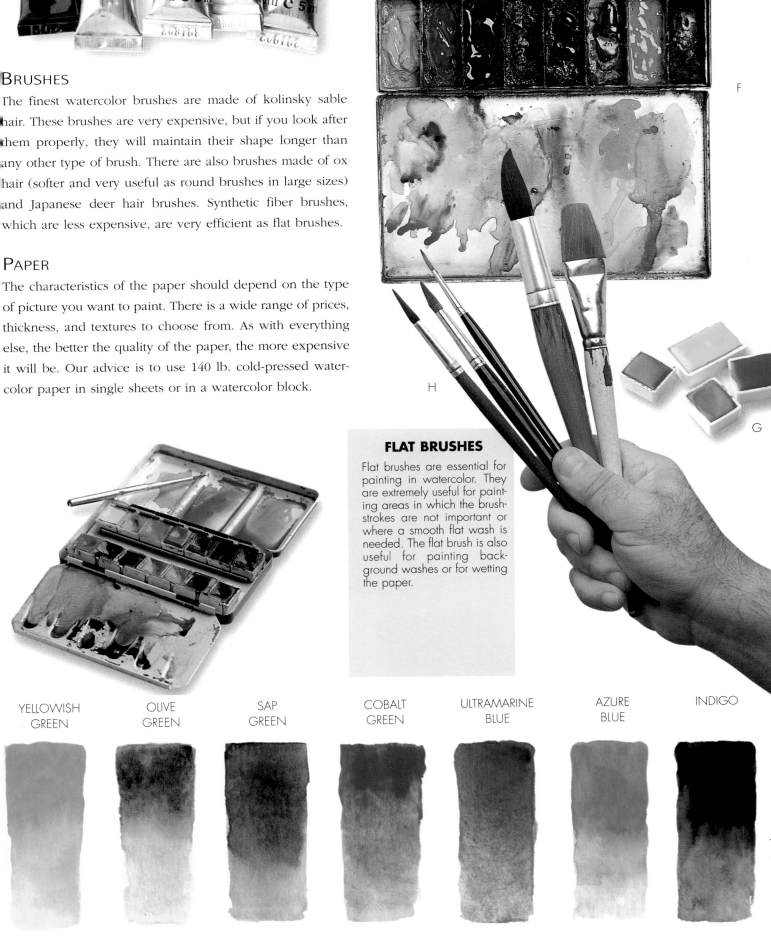

F

G

H

FLAT BRUSHES

Flat brushes are essential for painting in watercolor. They are extremely useful for painting areas in which the brush-strokes are not important or where a smooth flat wash is needed. The flat brush is also useful for painting background washes or for wetting the paper.

| YELLOWISH GREEN | OLIVE GREEN | SAP GREEN | COBALT GREEN | ULTRAMARINE BLUE | AZURE BLUE | INDIGO |

J

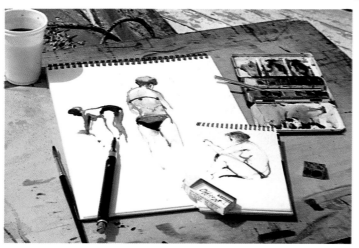

SKETCHING FROM NATURE

Sketching should be a daily practice for the painter, and for the figure painter this means drawing from a model. All experienced artists know how to draw and paint the human figure from memory, but there is no substitute for studying the form and color of your subject in real life.

The watercolorist should have appropriate equipment for working outdoors. It should be light and easy to set up and carry. Your outdoor equipment should include a large folder, preferably with handles, for transporting the paper and board (the folder itself can be used as a support), and a small travel bag to carry the bottles of water, brushes, box of watercolors, and any other items. If you prefer painting on drawing pads, a drawing board won't be necessary, although you may need the folder in which to keep your finished watercolors. If you prefer to work sitting down, you will find a folding chair or stool useful.

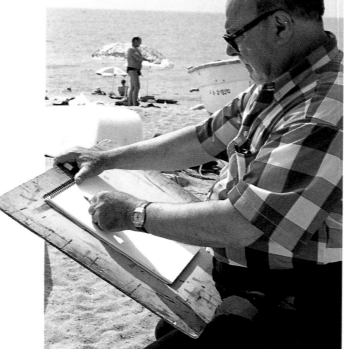

Once we have everything we need, we can set out, for instance, for the beach, where we can sit quietly and paint a variety of studies of men, women, and children in all poses, both in motion and at rest. You can paint your studies using any size and type of paper. Small works will be useful to refer to when we want to begin to work on large paintings in the studio.

ACCESSORIES

There are several other items that you will almost certainly need when you go out to paint: pencils, a soft eraser, a cup for holding the water, a roll of absorbent paper, a cloth or an old towel and, in the event of a sudden change in the weather, an umbrella.

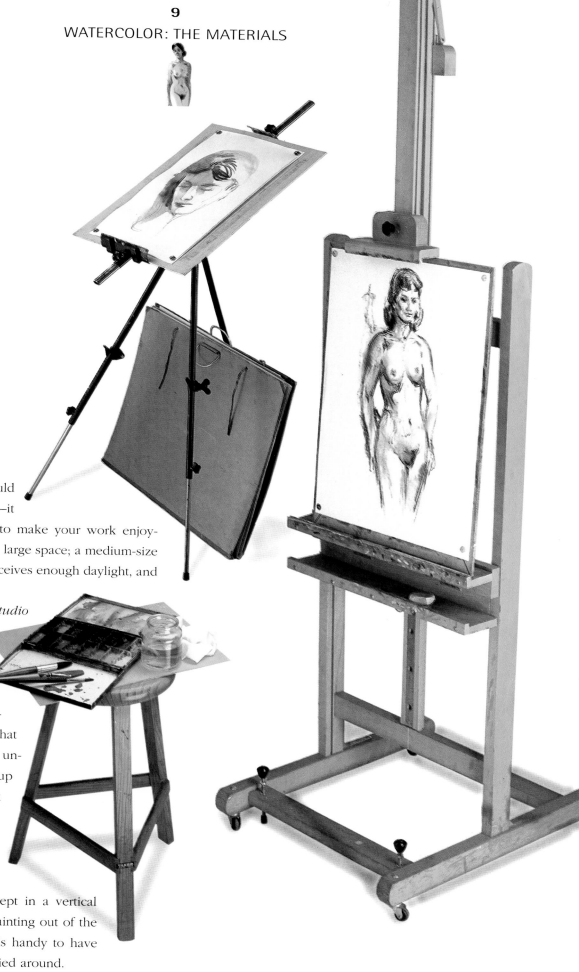

THE WATERCOLOR MEDIUM

Watercolor is one of the most difficult of all art media since it is not easy to mix and control the correct amount of water and paint each and every moment. It is therefore essential to carry out several trial runs beforehand. This can be done on scraps of paper, trying out different amounts of color with varying amounts of water, blending colors, lifting color to create white areas, creating mixtures of color on the palette and directly on the paper.

IN THE STUDIO

The watercolorist's studio should have one essential feature—it should be comfortable enough to make your work enjoyable. It is not necessary to have a large space; a medium-size room is sufficient, as long as it receives enough daylight, and is easy to keep neat.

The sturdiest easel is the *studio* type. It allows you to work with all sizes and formats on a vertical support. For those who prefer to paint on a slightly tilted horizontal surface, there are adjustable easels that are lighter. You will need a large, uncluttered surface for cutting up paper. Some artists use a desk easel on which they place a drawing pad.

Several portfolios of different sizes are necessary for storing your works, which should be kept in a vertical position. If you need to take a painting out of the studio to exhibit somewhere, it is handy to have a portfolio that can be easily carried around.

In addition to the tools and accessories mentioned, a small reference library of art books and magazines can give us ideas for our pictures.

WATERCOLOR TECHNIQUES

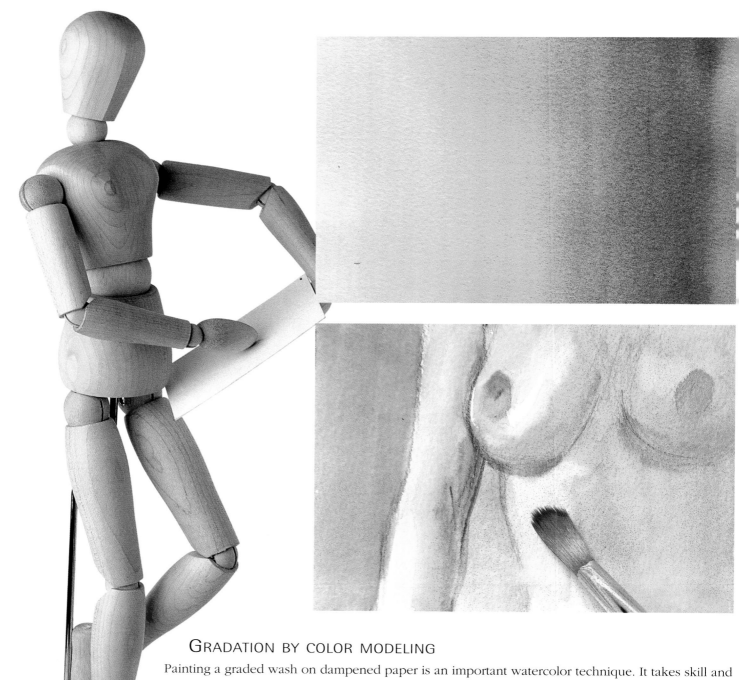

GRADATION BY COLOR MODELING

Painting a graded wash on dampened paper is an important watercolor technique. It takes skill and discipline to learn to control the right proportion of paint to water on dampened paper so that brushstrokes flow easily and do not dry too quickly. As long as the wash remains damp, the color can be intensified, blended, softened, or extended.

When painting the figure, working wet-on-wet is an excellent technique for application in modeling the volume of the body. It is possible to run a clean brush over a slightly damp or wet color to absorb or lift out some of the color. This creates a gradation from dark to light, an effect that represents the step from light to shadow on a rounded form. It is important to avoid breaks in the color or harsh edges that may occur when the color dries too quickly. The color should have enough water to keep it from drying while the modeling of the figure is developed.

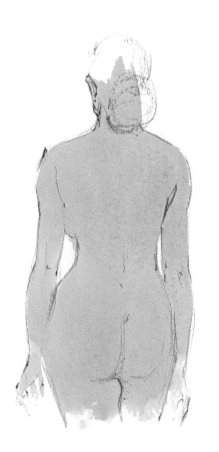

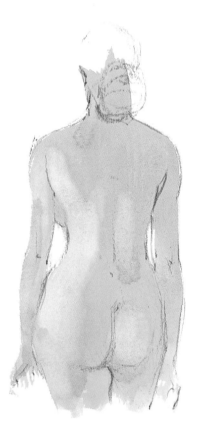

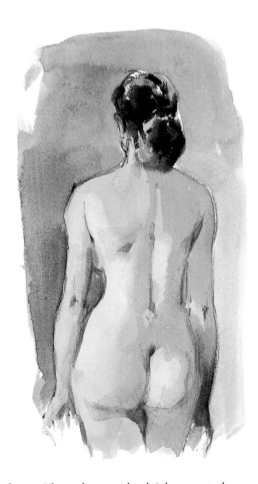

TWO WAYS TO BUILD FORM WITH VALUE

There are two ways to model the nude figure in watercolor. One is illustrated at the top of this page. A flat wash is painted over the entire body, then a clean brush is used to absorb and lift out some of the color. This creates highlighted and intermediate values of the figure. Once this base has been established, you can go on to include the details and the darkest shadows. The other method (shown at the bottom of the page) is to paint the darkest shadows using plenty of water, and then to move from these dark areas to create midtones and light areas by gradually adding more water to the paint mixture. Both techniques create a sense of form and depth.

SKETCHBOOKS

*T*he painter should always have a sketchbook and pencil handy for drawing at any time in any place. In addition to the valuable practice derived from sketching, it also provides the painter with a store of ideas and sketches for future watercolor paintings. The sketchbook does not have to be large, one measuring about 4¾" × 3½" (12 × 9 cm) is sufficient along with a pencil with soft lead. Other possibilities include a fountain pen, a felt-tipped pen, and even a ballpoint pen, as long as it is not too fine. Since these items are small, you can carry them in your pocket and draw wherever you choose. If you want to sketch using watercolor, there are several pocket-size paint sets that you can work with as easily as if you were drawing with pencil and pad.

FAST SKETCHES

In order to sketch quickly to capture the pose and gesture in few strokes, it is best to think in terms of basic forms, such as squares, rectangles, circles, triangles, circles, ellipses, and so on. No matter what pose the figure is adopting, it is possible to reduce the forms to basic geometric shapes, and sketching them becomes almost automatic. The combination of these forms is enough to suggest the figure; with four or five lines the hands, the legs, and the facial features can be suggested.

CARICATURES

Some portrait painters start with a good caricature. The caricature expresses character and emphasizes the most distinctive features of the subject. Regular practice in drawing caricatures enables us to learn to look analytically at the features. Diligent practice brings positive results in the long run as we acquire skill and confidence in drawing.

SKETCHES OF FIGURES IN MOTION

Drawing figures in motion is another excellent way to improve your artistic abilities. It is a matter of observation and memory, and the sketch should be quickly drawn without attempting to correct it. The studies shown on this page were sketched from television programs, from a soccer game, a folk festival, etc., which are some of the opportunities we have of observing the body in motion.

THE FIGURE AS SUBJECT MATTER

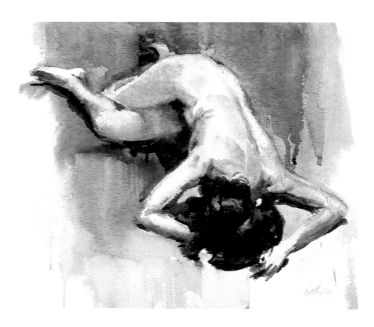

THE FIGURE AS SUBJECT MATTER

The human figure has long been a favorite subject for artists. The popularity of paintings of female nudes or of portraits is readily attested to by the many masterpieces of these genres that have been painted by great artists throughout the centuries. Using watercolor to paint either a nude model or one fully clothed provides an opportunity to explore the characteristics of this medium. There is a freshness and spontaneity to watercolor used to model the anatomy, to create rich flesh tones, and to develop contrasts of light and shadow. This is also true when watercolor is used for portraits, which we will discuss later in this book (see page 30).

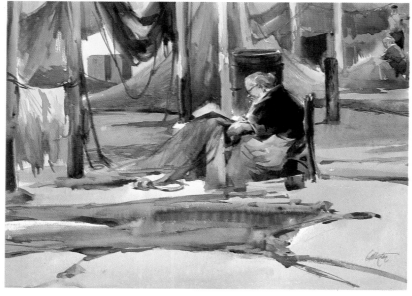

THE FIGURE AS PART OF A SCENE

The figure may be used as the center of interest or as one of the elements in a scene—in the city or in a landscape or the beach or countryside. In such cases, the artist must integrate the figure and the setting by balancing the various elements of the composition. It is easy to locate scenes in which the human figure appears to belong quite naturally. However, the artist is always free to create compositions by combining sketches of people and scenes drawn in different locales.

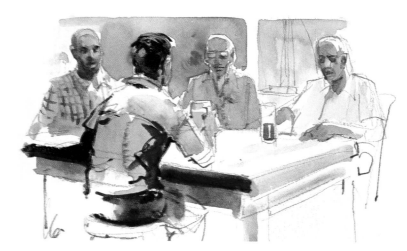

QUICK WATERCOLOR SKETCHES OF THE FIGURE

Whenever one encounters an interesting scene of a group of people, it is always an ideal opportunity to paint a watercolor sketch, working quickly on the scene. Bars, workshops, and social gatherings are just a few places that the watercolorist should visit armed with a pad and pencil in order to capture the scene of the group of people. The family is another excellent source of subject matter for fast sketches; it is much easier to capture family scenes, as well as being more convenient to paint at home.

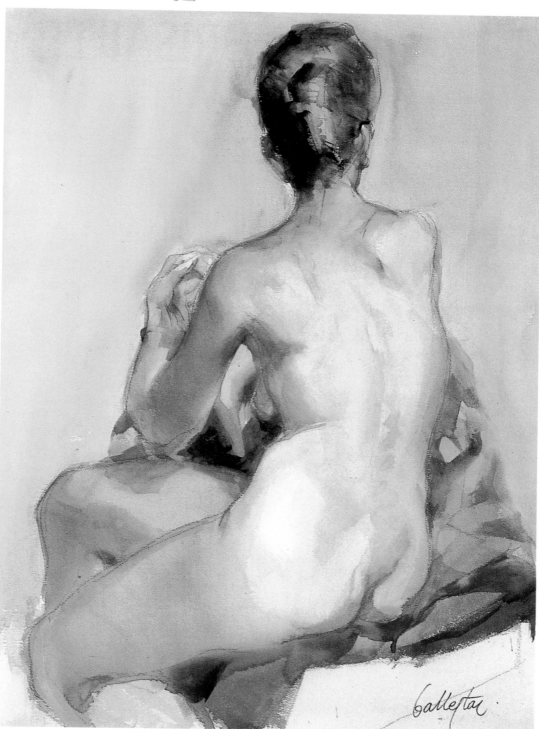

LIGHT AND DARK FLESH TONES

Light and dark flesh tones should be painted in different values of the same color, but this does not necessarily mean that the color must be limited. Warm colors (flesh colors and earth colors like sienna and umber) are good for dark and intermediate tones. Light values and highlights on the body should be painted in cool tones. The range of colors may include a color such as pale blue to paint subtle reflections.

MIXING FLESH TONES

The colors used to paint flesh tones are of primary importance when painting a human figure, especially a nude. Skin color varies according to the lighting (daylight or artificial light, whether direct or indirect, frontal or lateral, etc.) and also depending on the person. In watercolor, flesh tones are mixed from the colors you can see here on the left. The colors used are red, cadmium yellow medium, burnt sienna, permanent green, and ultramarine blue. The warm colors in this palette are used for the warm tones of the skin, while the cool colors (green and blue) are used to paint reflected light and halftones.

A FEMALE NUDE IN GRISAILLE

The first exercise in this book consists of painting a frontal view of a female nude (or semi-nude) in grisaille (a neutral gray). The theme and the pose are classics. They possess a harmony and elegance that I believe is evident, and to highlight them I have chosen a slightly indirect source so as to not dramatize the beauty of the forms—soft lighting highlights the model without creating excessive chiaroscuros. I think we now have all the essential elements for painting an interesting watercolor.

MATERIALS

- Rough watercolor paper, 14" × 20" (38 × 46 cm)
- Soft pencil (2B)
- Round ox hair brushes (4-10)
- Flat brush of synthetic fiber, ¾" (2 cm)
- Tube colors: ultramarine blue, alizarin crimson
- Dish for mixing colors
- Old towel and absorbent paper

The hair is a dark value, almost black, which has been mixed by combining equal parts of alizarin crimson and ultramarine blue in a highly concentrated proportion of both colors. The result is an intense color that is close to black. Grisaille is usually a monochromatic gray, but here it is mixed from two colors.

The background has been moistened with plenty of water. The use of thoroughly dampened paper enables me to create very soft gradations of value, from a nearly transparent value to a very dark one. This graded wash is painted with the flat brush.

The folds and creases are suggested by adding details to the initial wash laid down to establish the main shadows. I have drawn the creases on top of the wash, once it has dried, using the tip of a round brush following the lines marked out in the initial drawing.

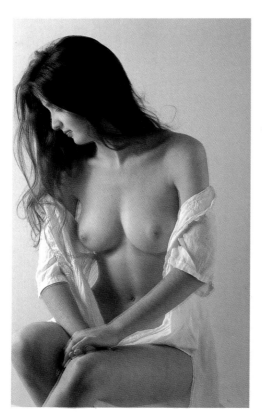

1 The initial drawing may be simple and schematic or elaborate and rich in details. In this case, I have drawn the figure with care, marking out not only the anatomical details but also the outlines of the shadows.

2 I have mixed some ultramarine blue and alizarin crimson in a dish to make a very dilute wash of violet blue, which I now apply on the paper that has been previously moistened with clean water.

The breast has been painted, but the color is so transparent and toned down with water that you could almost mistake it for the white of the paper. Thanks to the graded washes, the transition between the pale color of the breast and the shadows is gradual without abrupt breaks.

The modeling of the torso has been done by toning down the color (following the procedure explained in the pages devoted to watercolor techniques, pages 10–11). With a clean, nearly dry brush I have lifted color to create the light areas. The dark value of the previous wash establishes the shadows.

3 I am using very diluted color, constantly adding water in order to paint a smoothly graded background wash. By working quickly and evenly, the transitions are subtle, and no brushstrokes are visible.

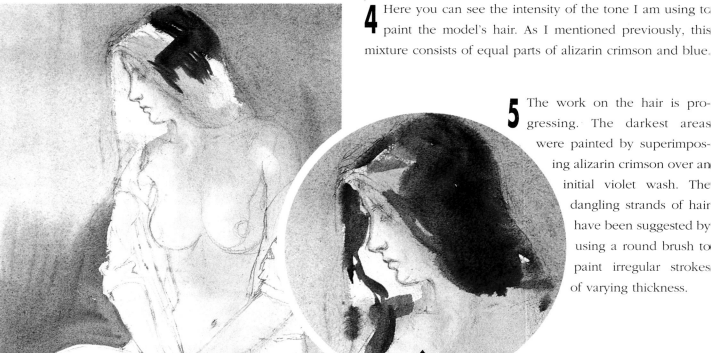

4 Here you can see the intensity of the tone I am using to paint the model's hair. As I mentioned previously, this mixture consists of equal parts of alizarin crimson and blue.

5 The work on the hair is progressing. The darkest areas were painted by superimposing alizarin crimson over an initial violet wash. The dangling strands of hair have been suggested by using a round brush to paint irregular strokes of varying thickness.

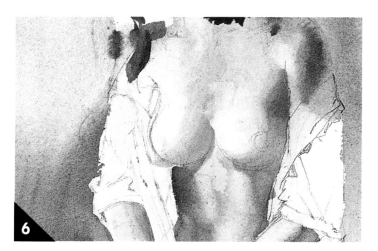

6 I begin the modeling of the body, always working wet-on-wet. Moistened paper allows me to create shadows that flow smoothly, blending into lighter areas without abrupt breaks.

CORRECTING MISTAKES IN WATERCOLOR

It is often said that it is not possible to correct errors in watercolor. This is not completely true. In many cases, mistakes can be corrected if you use good paper. If you use a poor quality paper, the surface may be spoiled or scarred as you remove color with water, razor blades, or sandpaper.

7 Having completed the first stage of the modeling, I can now work on the blouse, which I left white. I start with the most intense colors and follow the folds of the sleeve that have been defined in the drawing.

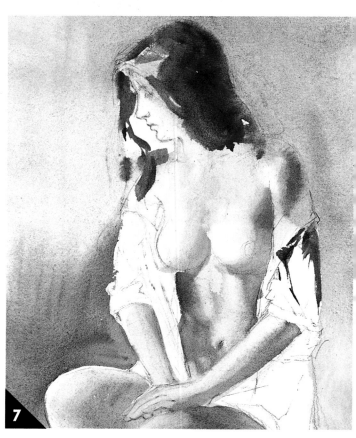

8 Here you can see how I resolve the mass of hair and the dangling strands. On top of the head, I had left a light area that I now cover with very dark parallel brushstrokes. The result is a highlight or the effect of numerous highlights where the light shines on the hair.

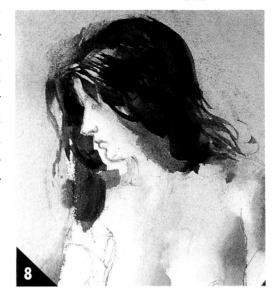

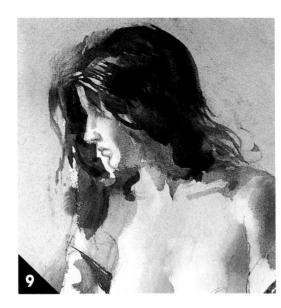

9 Now let's see how I begin to model the face. With a very dilute color and a flat brush, I paint a curving brushstroke following the line of the cheek. The chin is left white to emphasize its rounded form. In addition, I lightly shade the socket of the eye with a very diluted color.

10 Now I am darkening the right shoulder. The main difficulty here is to differentiate between the shadow and the hair. I solve this problem by using a lighter value and, above all, a much more transparent tone to paint the shoulder.

11 On the opposite shoulder, the shading is also very light. I leave visible the soft line of subdued color that runs from this shoulder to the neck, since it indicates the position and shape of the collarbone.

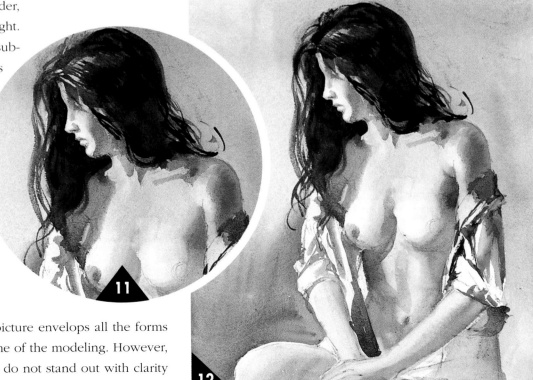

12 The general tone of the picture envelops all the forms and begins to suggest some of the modeling. However, it is still too soft and the forms do not stand out with clarity and definition.

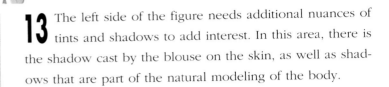

13 The left side of the figure needs additional nuances of tints and shadows to add interest. In this area, there is the shadow cast by the blouse on the skin, as well as shadows that are part of the natural modeling of the body.

14 I work on the main part of the body with small strokes of transparent washes. I try to avoid harsh contrasts between the skin color and the darkness of the areas in shadow, thus maintaining the softness of the body.

15 The figure is almost complete and now the relationship between the close values of the figure and of·the background can be seen. The smooth, flat wash of the background provides an excellent counterpoint to the modeling of the figure. In addition, the dark value of the hair serves as an essential contrast in a watercolor like this that is painted in subtle neutral tones.

16 This is the final result. I believe everything I set out to do has been accomplished. This exercise is an excellent way to learn to delineate form and volume with only a single neutral gray. Practice with monochromatic washes and neutral grays, or grisaille, is the best preparation for mastering watercolors in full color.

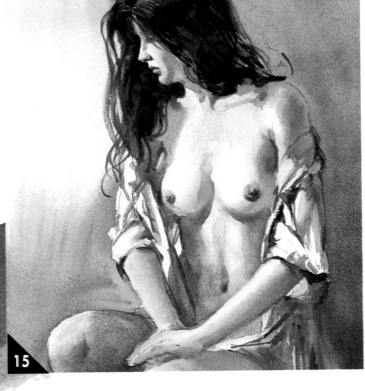

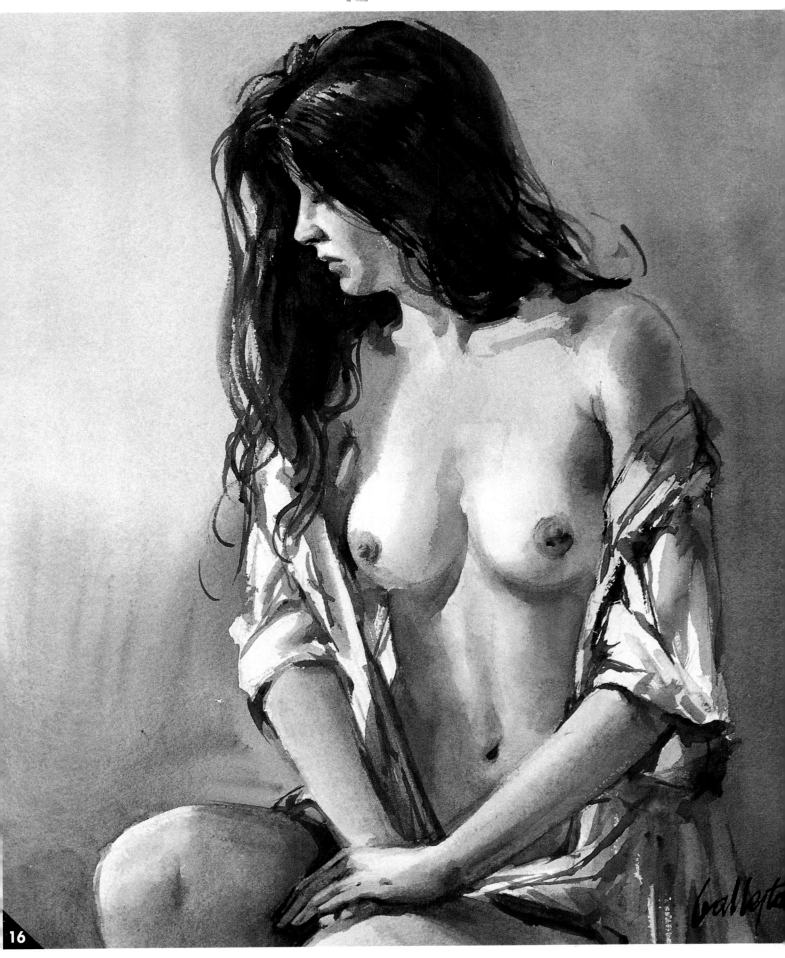

A HARBOR SCENE WITH FISHERMEN

*O*ne of my favorite places for taking notes and sketches, and also for painting watercolors, is a fishing harbor. The harbor combines both the natural landscape and the human landscape, the sea and the work of the fishermen, the boats, fishing tackle, cranes, wharfs, and so on. Whenever I visit such places, even without searching for one, I invariably find an inspiration for a watercolor. On this occasion, the subject matter I have selected consists of a group of people, possibly a family, repairing the fishing nets. There are four figures, an excellent subject for studying and practicing the painting of the human figure in its own environment.

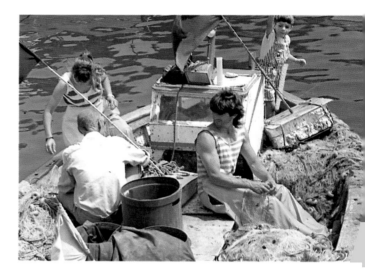

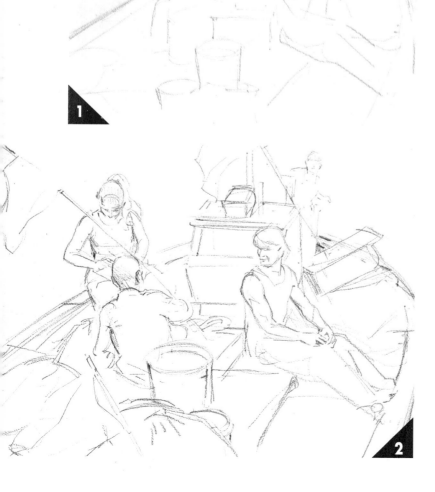

1 The scene offers a rich diversity of shapes and planes. It requires a detailed initial drawing to correctly position the figures. As you can see, the oval shapes of the boat's deck is the basic form that frames the scene. The size and curve of the oval should be used as a guide for situating the rest of the compositional elements.

MATERIALS

- Rough watercolor paper 14" × 20" (38 × 46 cm)
- Soft pencil (2B)
- Round ox hair brushes (4-10)
- Flat brush of synthetic fiber, ¾" (2 cm)
- Tube colors: ultramarine blue, cobalt blue, burnt sienna, alizarin crimson, cadmium yellow, cadmium red, and Van Dyck brown.

2 Once I have placed the figures in the composition, I start to draw them in greater detail. I want to make sure that the people are logically placed on the deck, so that the space between the figures and the objects are in the correct proportions.

The sea around the boat was painted with a wash of ultramarine blue, which varies in tone, with a darker value at the top.

I simplified the figures as I painted them, developing the forms by means of light and shadow, in the style of the Impressionists.

The cabin of the boat was left unpainted. I then shaded the white of the paper with a very pale gray in certain areas, leaving others pure white.

The nets and tackle that are piled up on this side of the boat require a simplified treatment, like a bundle with a few details that suggest what they are.

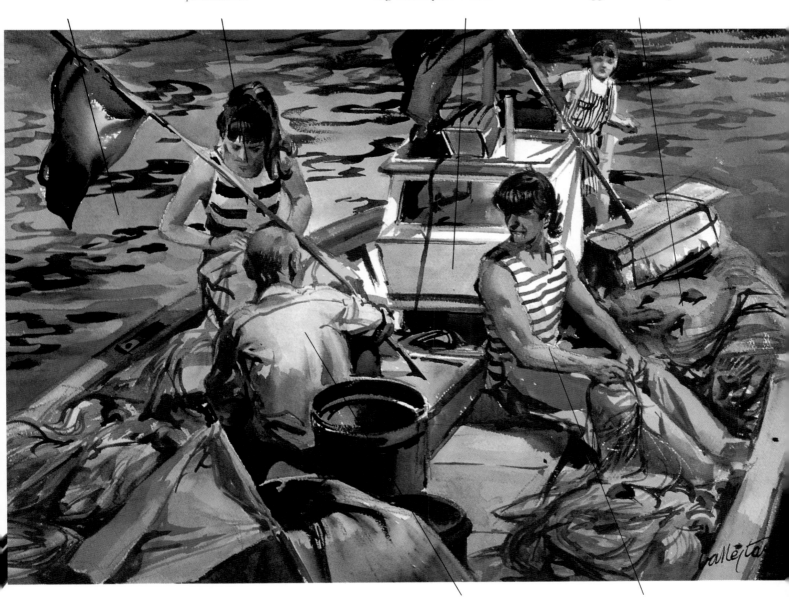

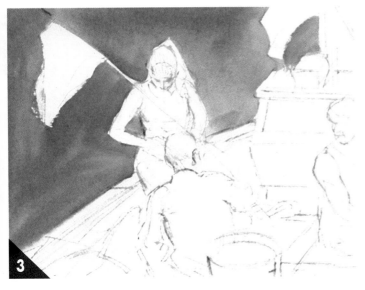

We can estimate this man's size by the shape of his back. This is painted with cobalt blue, using a very light value around the shoulders (the lightest area), and a darker value in the area of the belt.

This is the figure that stands out in the composition; however, it is painted in a simplified way, following the lines of the sketch. The anatomy of the arm is suggested merely by the contrast of light and shadow.

3 I begin work on the upper left part of the picture, painting the water with ultramarine blue and leaving everything else white. You have to take the utmost care when preserving white, respecting the contour lines of the initial drawing without going over them. This blue tone is more or less uniform with variations in its intensity to indicate the distances.

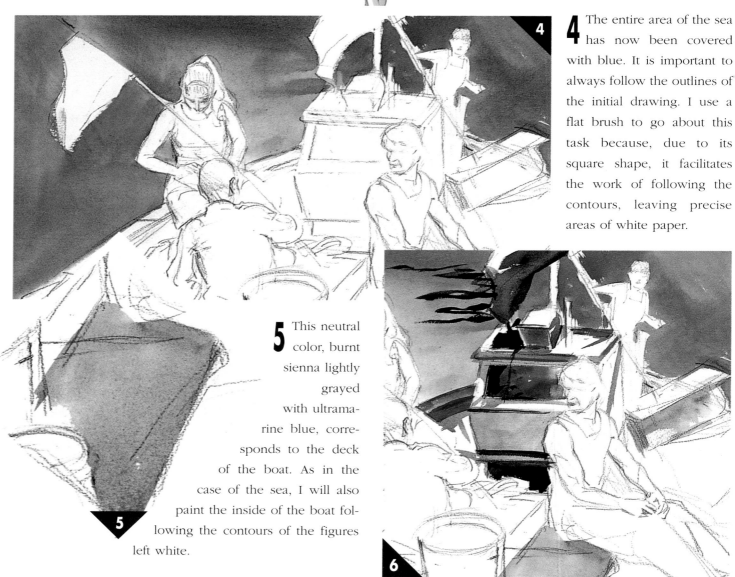

4 The entire area of the sea has now been covered with blue. It is important to always follow the outlines of the initial drawing. I use a flat brush to go about this task because, due to its square shape, it facilitates the work of following the contours, leaving precise areas of white paper.

5 This neutral color, burnt sienna lightly grayed with ultramarine blue, corresponds to the deck of the boat. As in the case of the sea, I will also paint the inside of the boat following the contours of the figures left white.

6 The cabin also requires preserving white areas. In this case, it is relatively easy, since it is square in shape without any significant irregularities.

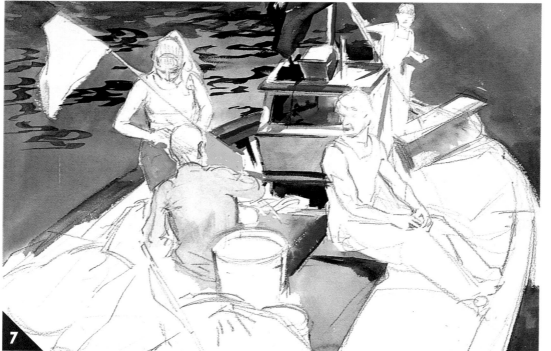

7 Now I begin working with warm colors—cadmium yellow and red—to paint the side of the boat and several boxes that can be seen in the center. I darken the orangish tone of this mixture with burnt sienna.

8 I now begin to paint the figures. In this illustration, you can see the first applications of color in the figure on the right side of the composition. I use very watered down burnt sienna to paint both the pants and the arms of the figure.

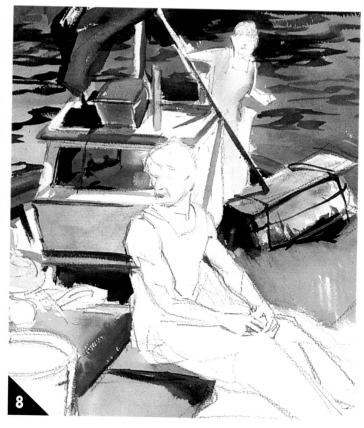

9 Now I turn to the figure on the right. Up to this point, I had left this figure unpainted, surrounded by the colors of nearby elements. I first mix a pale wash that I will use as a base color for the illuminated and shadowed areas of the form.

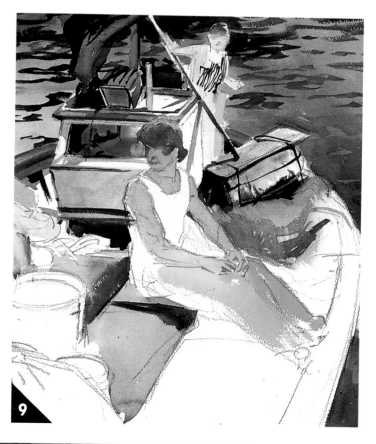

10 Gradually the scene begins to take shape. Forms and colors emerge against the white areas or the dark colors around them.

PRESERVING WHITE AND OUTLINES

Preserving white and outlining forms are important in this watercolor. They are not difficult to handle correctly, as long as you do it carefully. Be sure to use the initial drawing as a guide, taking care to follow the contours established.

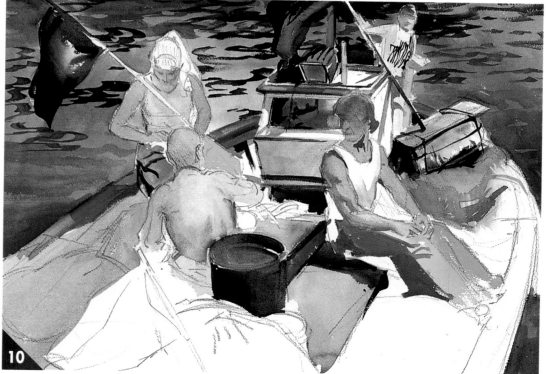

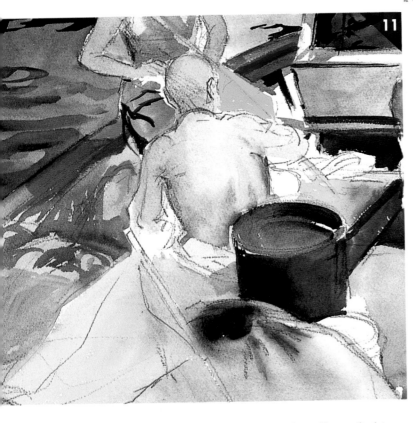

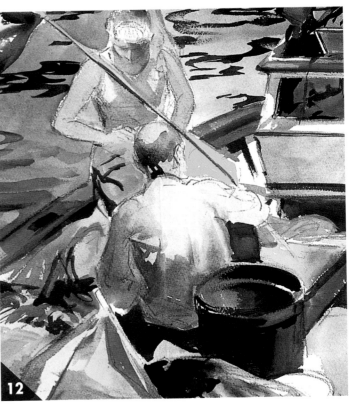

11 Here we can observe how the watercolor progresses from light to dark or, to be more precise, from diluted colors to intense tones. The water now includes ripples painted in a very dark mixture of dark blue and raw umber. The fishing nets are only half finished and I have begun to paint them, adding details to the base color.

12 This is one further step toward the effect of chiaroscuro with its dramatic variations of light and shade. The fisherman's shirt is modeled in ultramarine blue, while the can and sailcloth, seen in the foreground, have been painted in cobalt blue.

13 I pause to take stock of my work. Everything is going exactly according to plan; the forms have been established and complement one another. The figures have been modeled and all that remains is to add some details. The mosaic of colors has been adjusted properly according to the distribution of objects.

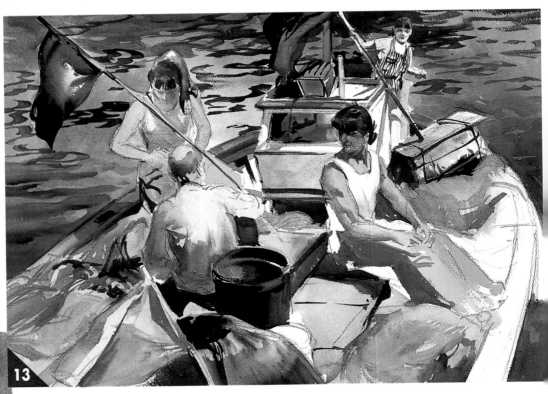

14 One particular detail should be considered— the intensity of the tone of the water. This should be a value halfway between the body of the young woman (lighter) and her head (darker). This way, the figure does not stand out too much against the blue background.

15 I add new details to the figures. Some of them are very subtle, such as the shadows and the treatment of the hair of the man with his back turned to us. Other details are more obvious, such as the stripes of the young woman's T-shirt.

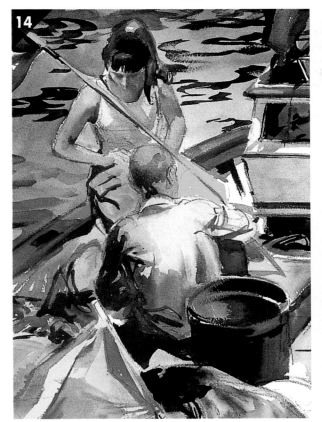

16 This detail shows the treatment of the hair. For this very delicate work, I used a number 4 ox hair brush to define the bangs and the facial features, working with great care, on a dry surface. Once this is done, the play of light and shadow on the girl's head is complete.

17 As you can see here, the exercise is practically finished. It includes interesting details, such as the stripes on the child's clothing, painted with a series of fine lines that capture the forms and folds. The nets have been treated in a combination of a simple wash and careful detail, which creates an effect of solidity and volume.

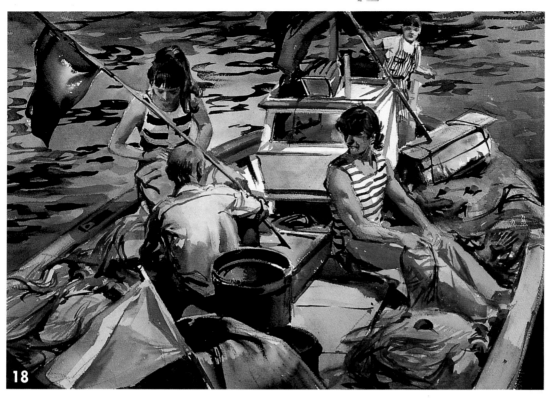

18 To heighten interest in the nets, I have drawn a number of lines with the tip of a brush loaded with a wash of burnt sienna that is darker than the base color. These wavy lines suggest an intricate heap of ropes and nets spread out over the deck.

FINISHING DETAILS

Watercolors like the one here require detailed finishing touches because of the complexity of the composition with its variety of elements and contrasts of color. Parts of the scene, like the nets, need more detail. Nevertheless, the artist has to know when to stop—too many details can make a painting look too busy.

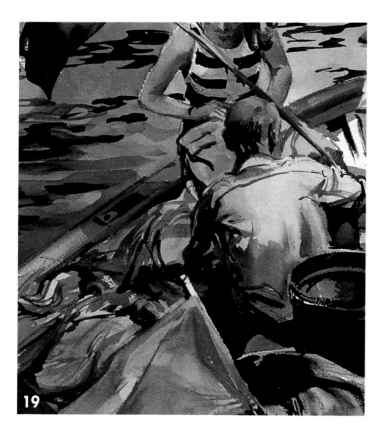

19 This is a detail of the nets in which you can see that the watercolor is nearly finished. These wavy lines, superimposed over the base color, have a reason for being there—they add interest and authenticity to the scene.

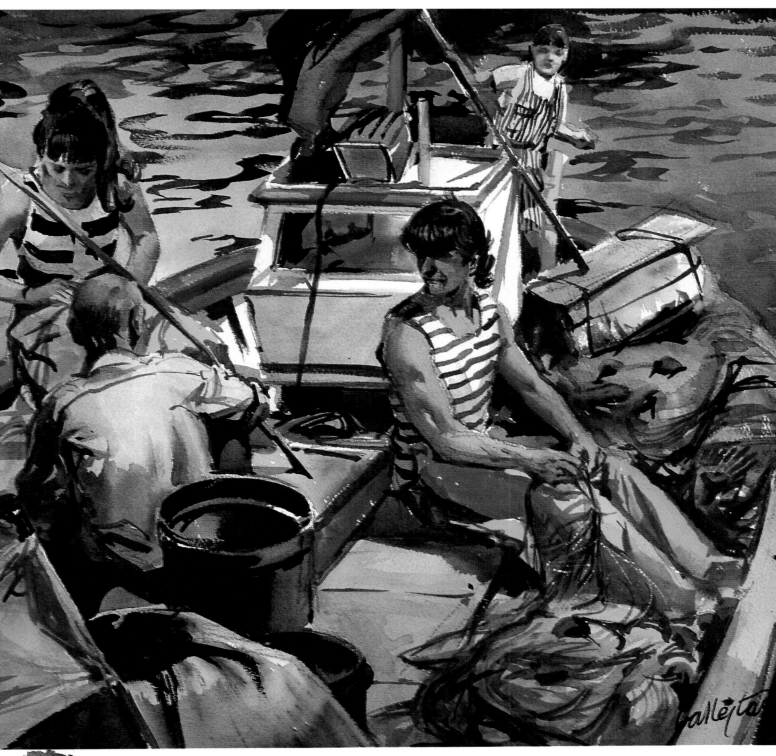

20 With the finished work before me, I can see that, despite the many different elements, the forms and the lighting blend harmoniously. The scene consists of four figures in different positions, something that may seem difficult to organize, but one that can be successful as long as we start out with a good drawing and a good composition. Once we have a good initial drawing, everything else is a matter of methodical work and a systematic treatment of light and shadow.

PORTRAIT OF THE ARTIST'S MOTHER

*F*amily members often end up as "victims" of the painter; they patiently pose and are readily available. In this exercise, I have asked my mother to pose while she goes about one of her chores. I believe this watercolor will be an excellent demonstration of how a watercolor can capture elderly people. This is a classic theme in the portrait painter's repertoire and in the painting of human figures in general, proof of which can be seen in the magnificent portraits by Rembrandt. Our objective is rather more modest.

MATERIALS

- Rough watercolor paper, 18" x 22" (46 x 55 cm)
- Soft pencil (2B)
- Round ox hair brushes (4-10)
- Flat brush of synthetic fiber, ¾" (2 cm)
- Tube colors: cobalt blue, burnt sienna, alizarin crimson, burnt umber, cadmium yellow medium, cadmium orange, cadmium red medium, and permanent green deep.

The wall is painted with an unblended cadmium yellow medium, applied in strokes of uniform intensity. This warm tone adds luminosity to the entire composition, creating a pleasant contrast to the deep blue of the blouse.

This shadow is painted in different values of burnt umber. The edge of the shadow is lightened until it completely blends with the yellow wall. The darkest shadow is the intense pure color.

The blouse was painted with a very dark blue, black in certain zones, the result of mixing ultramarine and burnt umber.

1 First a careful study is drawn, which contains details of the facial expression and even certain shadows. This drawing should be closely followed, from start to finish, when I start to paint; therefore, I take as much time as I need to draw a correctly proportioned figure.

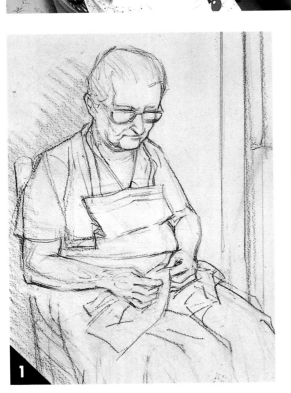

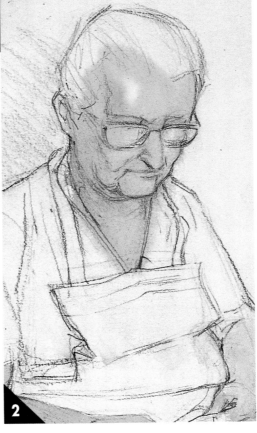

2 Using a mixture of cadmium orange and burnt sienna, toned down with water, I paint the flesh. Over this general wash, I can work with a clean brush as I begin to model the form. By lifting some of the color with a clean dry brush, I create a highlight on the forehead and lighten the tone.

The forehead has undergone a subtle treatment. Using a soft wash, worked wet-on-wet, I suggest the ridges of the wrinkles.

The entire apron has been painted with a series of gray washes. This gray is a mixture of ultramarine and burnt sienna. In places, the gray is so diluted it appears white.

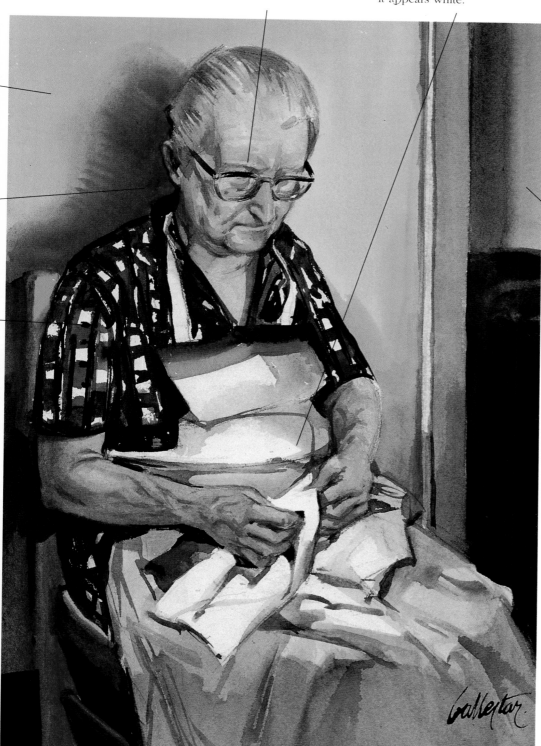

I have painted this strip in the background, the most distant plane in pale blue. The contrast of the blue with the yellow-orange of the wall, makes it recede into the background, creating the sensation of space.

3 I have intensified the flesh tones slightly. I have also applied the first brushstrokes to the hair, several very light gray ones applied in a diagonal direction, following the direction of the hair, which is pulled back.

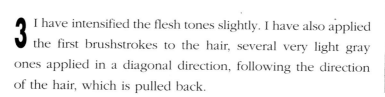

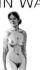

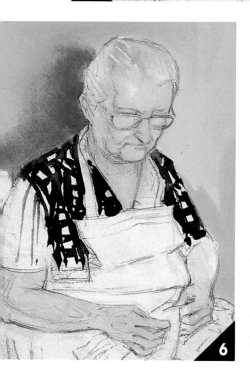

4 I have covered the wall in the background with a was of cadmium yellow medium without mixing it or varyin its intensity. You can see how the contrast suggests the e derly woman's gray hair.

5 I finish painting the shadow behind the figure with burn sienna, a color that goes well with the yellow. This im mediately darkens the work.

DARK VALUES

In watercolor, you can always darken values by means of successive layers of color. It is better, however, to make the first wash dark enough, rather than to darken it by superimposing other colors, because this tends to muddy the color. It is important that a color added to darken another color (for shadows, for instance) should relate to the overall harmony of the painting.

6 The color of the blouse is almost entirely black, not a black straight from the tube but a mixture of ultramarine blue and burnt sienna. This is a strong contrast that creates a sensation of distance with respect to the wall in the background. The white squares of the pattern of the blouse are the unpainted white of the paper. The dark area was painted using a flat brush.

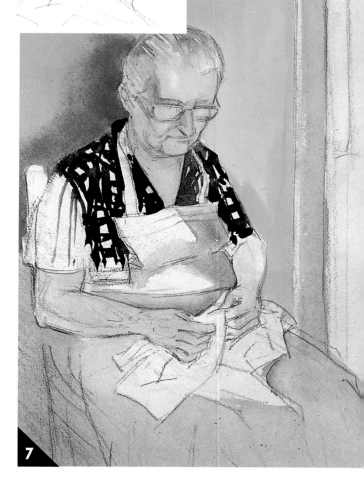

7 I have covered the entire lower half of the figure with a gray wash that I will use as a base for working on the grays in the apron. The cleanest whites (those of the cloth that the figure is holding in her hands) I have left unpainted until I finish the apron.

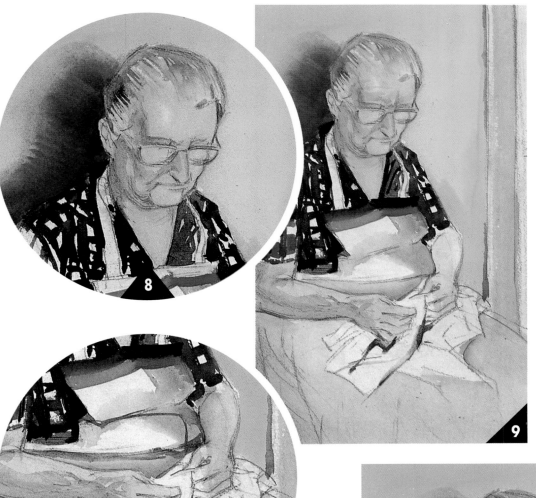

8 Paying close attention to the general effect, I work on the figure as a whole. Here I finish adding soft shadows to the hair, painting strokes that follow the direction of the hairstyle, darkening the part toward the back.

9 I work on the shadows on the left side of the face, carefully adding details. I add strokes. They are shaded areas of well diluted, grayed sienna. The color appears darker once it is applied, due to the effect of the color on the lower part of the face. The shadows in the arm have also been developed in the same way.

10 The hands require careful attention. I need to develop nuances of color in the shadows. I also need to emphasize the contours of the hands, which I am now working on by darkening some of the folds in the cloth.

11 I take a moment for reflection before continuing the work. A glance at the picture shows that the upper half of the figure is finished while the lower half still requires some work on the folds of the apron.

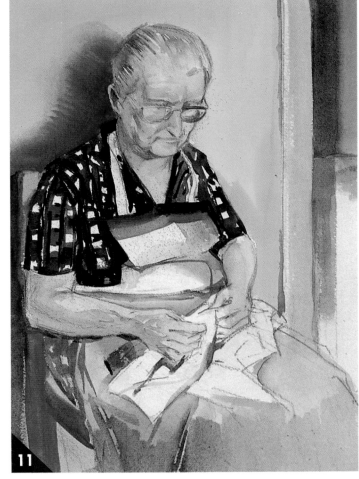

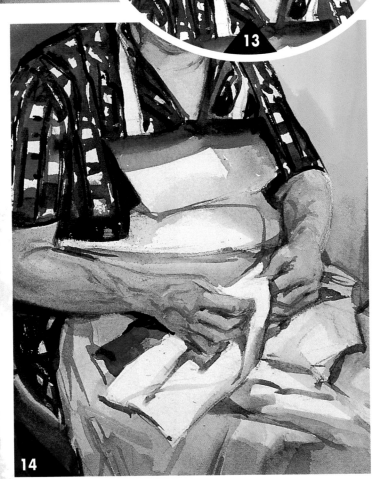

12 I now work on the lower part of the chair with burnt sienna and cadmium yellow, painting the cylindrical form that merges into the darkest part of the background shadow. Next, I move on to the background strip and paint the upper part pale blue. I then mix a darker color with ultramarine blue and yellow for the lower part.

13 The frame of the woman's eyeglasses and the shading of the lens are the final details of the upper part of the head. I have also intensified the shading of the lower part.

14 In this detail, you can see the finished work on the arms, hands, and apron. Form and volume have been developed, and the shadow on the arms contrasts with the apron. Finishing touches are added to the lower part of the apron. A few brushstrokes indicate the folds and creases in the cloth. The darker grays in the lower area add a three-dimensional feeling to the painting.

15 I have decided that the watercolor is finished. I do not wish to add anything more that may detract from the center of interest, which is the theme of the portrait. I am satisfied with this work. I believe that in my treatment of this quiet scene, I have taken advantage of dramatic use of color, contrasting yellow and black. The choice of color adds interest to the traditional realism.

DRAPERY

Drapery consists of clothing or any fabric that creates folds and creases. Painting drapery in watercolor can be done in a number of ways, but one of the most effective ones is to follow the folds of cloth with brushstrokes in order to show how the fabric falls. They should be vigorous strokes, painted with a medium-size brush, loaded with a large amount of water and paint, so that the characteristics of the fabric will be captured.

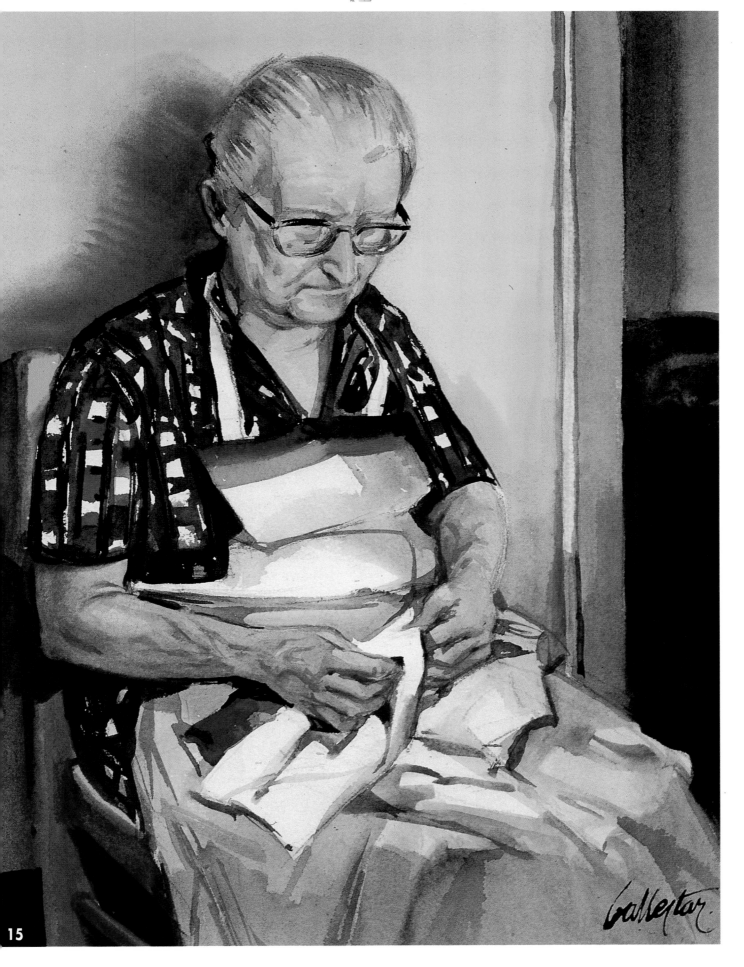

A STREET SCENE

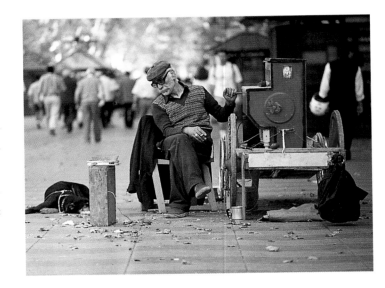

*E*veryone who paints or sketches will occasionally discover ideas or subject matter that appear unexpectedly without having to search for them. For those who reside in cities, this happens all the time, and very often we are caught unprepared, without a drawing pad or pencil and paper. This organ-grinder, with his barrel organ and his dog, is a scene worthy of any artist's attention, and any artist would regret not having a sketchbook to record such a sight. We have photographed the scene for this book and for the exercise that follows, an exercise that could also be painted on the scene since it is rather static.

MATERIALS

• Rough watercolor paper, 14" × 20" (38 × 46 cm)
• Soft pencil (2B)
• Round ox hair brushes (4-10)
• Flat brush of synthetic fiber, ¾" (2 cm)
• Tube colors: yellow ochre, burnt sienna, alizarin crimson, cadmium yellow, sap green, and cadmium red medium
• Palette with wells for holding the colors
• Old towel and absorbent paper

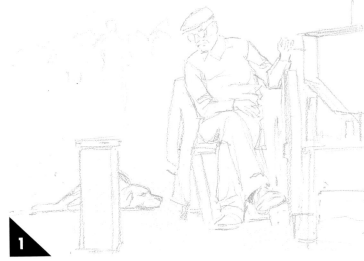

1 A key to a successful street scene in watercolor is knowing how to focus on the subject without paying too much attention to extraneous background objects. As you can see in the initial sketch, I have drawn most of the surroundings abstractly in order to concentrate on the figure, his dog, and the barrel organ, which I have drawn with greater precision.

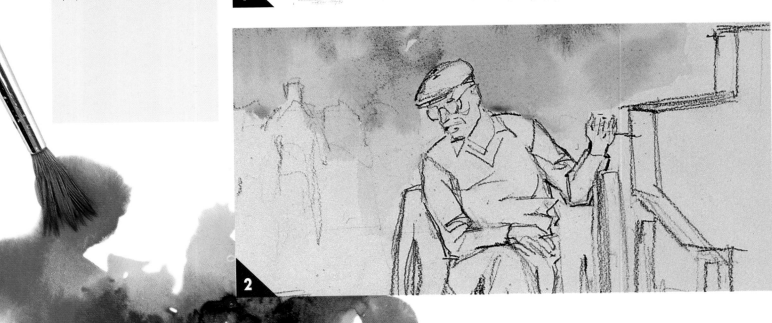

This area of the watercolor has been painted without a previous drawing, working directly with color and letting the brushstrokes suggest several people in the background.

The organ-grinder's jacket is the darkest value in the composition. It has been painted with a mixture of blue, alizarin crimson, and burnt sienna. It provides a strong contrast to the white paper.

The figure is the most detailed element in this watercolor. It has been painted by concentrating on a distribution of light and shadow using neutral colors (gray and burnt sienna).

The barrel organ is an accent note of pure red, without highlights or shadows. This flat color helps to stabilize a composition as open and full of atmosphere as this one.

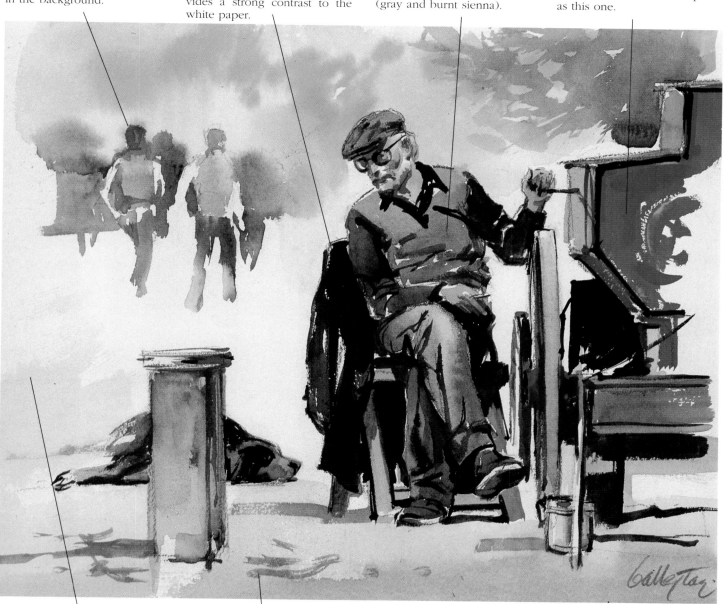

The white of the paper can be seen; I have left this part unpainted to create a sensation of depth.

I have darkened the foreground to create a more solid base for the scene. A soft neutral gray is used here.

2 I start by painting the sky, in this case the treetops of the avenue where the scene takes place. I use very diluted sap green applied in different intensities to suggest the delicacy of the foliage.

3 This is a detail that serves to evoke the street atmosphere; several figures that appear in the background are painted with very free brushstrokes.

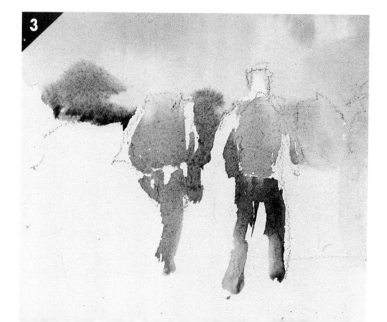

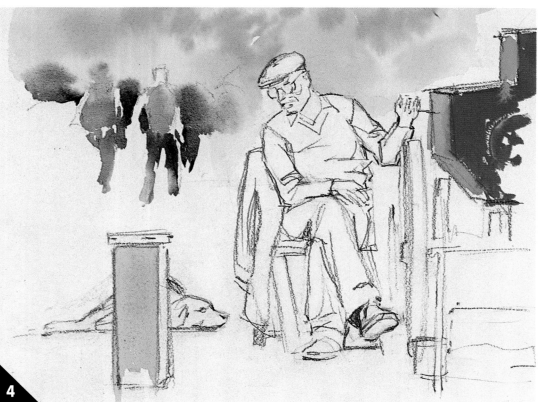

4 I begin with the most intense colors, the flat colors that do not require any modeling. The red on the right is pure cadmium red. Next to it is the lighted side of the barrel organ painted with cadmium orange. I mix these two cadmiums with yellow ochre to create the color of the box on the left.

5 The basic color of the man's sweater is a light value of burnt sienna in the center and a darker value of this color on the lower part. Now I start on the first creases.

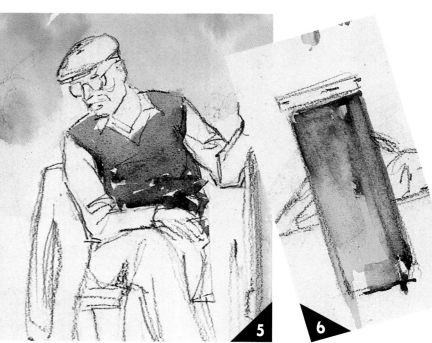

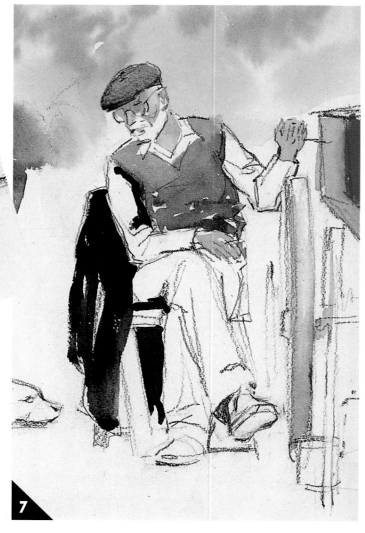

6 With the same burnt sienna used to paint the sweater, I now tone the color of the box in order to suggest the color of its old wood, working with color mixed with a large amount of water.

7 These dark strokes, corresponding to the jacket that is hanging over the back of the chair, are painted with a mixture of ultramarine blue, alizarin crimson, and burnt sienna.

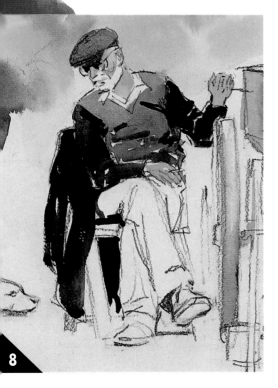

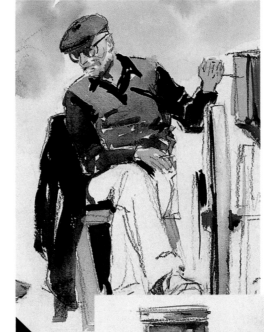

8 With an intense burnt sienna, I paint the sleeves and collar of the shirt. The color is dark enough to harmonize and blend with the color of the jacket.

9 The organ-grinder's face is painted with a very light burnt sienna wash, leaving the beard in white. Now, I shade the lower part of the beard.

10 I am now working on the trouser legs. I go about this by laying down a dark gray wash over which I work on the folds. The nose of the dog is also painted with the first strokes of sienna. The rest of the dog will be painted with the same dark color that I used on the jacket.

PAINTING FIGURES WITHOUT PRELIMINARY DRAWINGS

In urban landscape watercolors, groups of people or crowds do not need to be precisely drawn because their movement cannot be captured in a single moment. Therefore, it is best to suggest the movement of people with color, which should always be soft and tenuous so as not to create clashes.

11 The man and the dog, the main subjects, are almost complete. I want to keep the soft atmospheric feeling in the work.

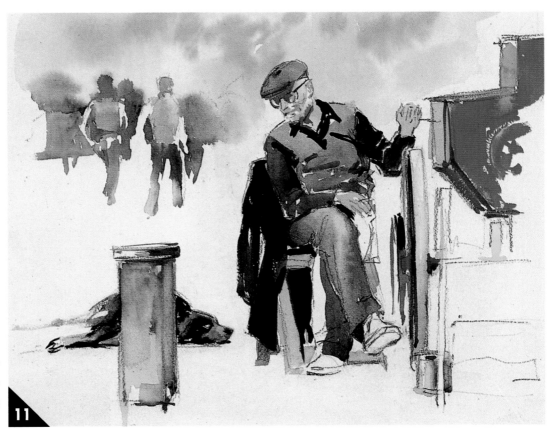

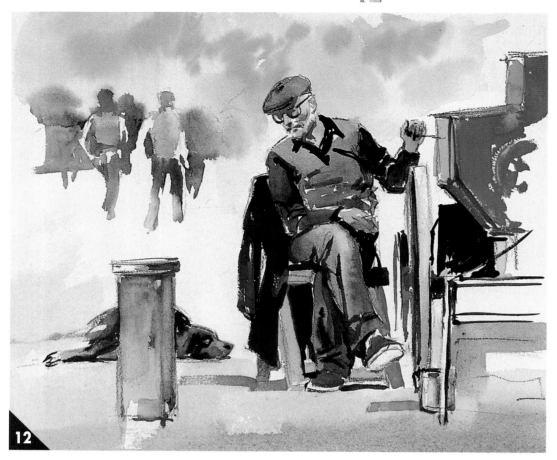

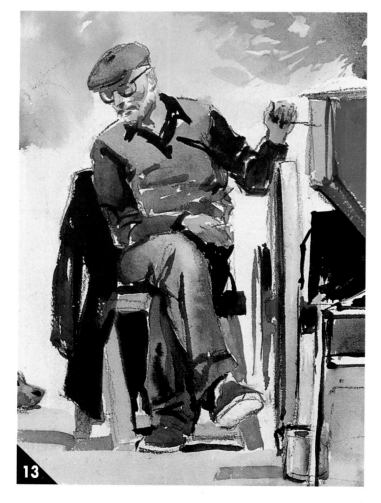

12 Here we can see the grayed blue wash used to paint the organist's pants. Over this base color, I paint the folds with the same tone I used for the jacket. The dog also has some of this dark color, but its nose is painted in burnt sienna.

13 The figure is complete except for a few details, such as the shadow on the organist's head. Here I add burnt sienna with a number 4 brush, drawing the glasses with the same brush and color. The only remaining task left is to finish the shoes.

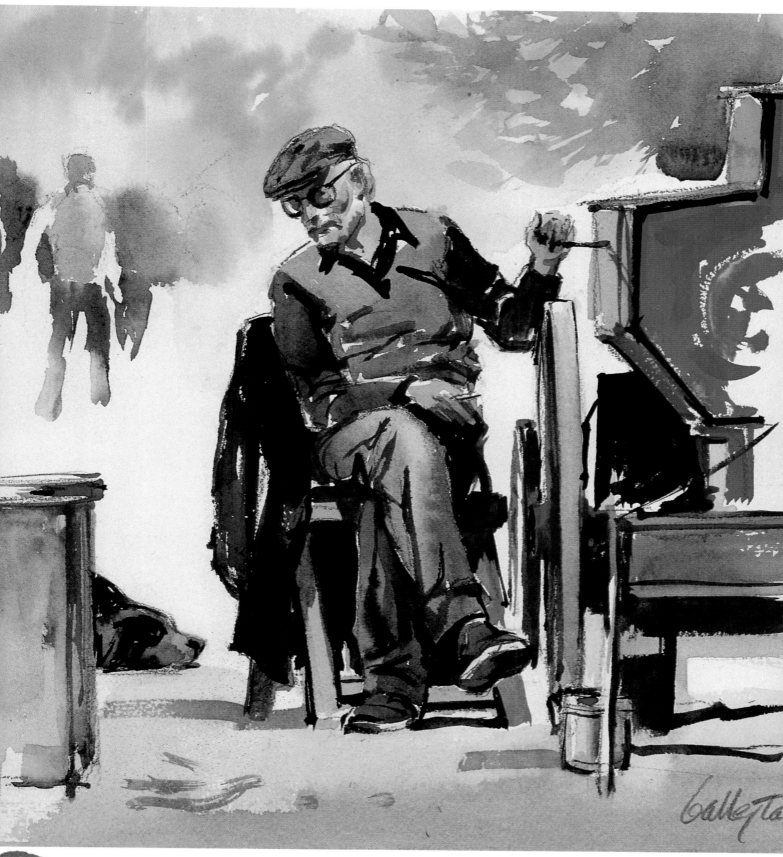

14 The exercise is finished. It has turned out well. Subjects like this always have a special charm and it is a pleasure to paint them in watercolor. Although it is usually preferable to paint watercolors on the scene, from nature, it is also possible to paint from photographs.

PORTRAIT OF AN ELDERLY FISHERMAN

*W*e return to painting a portrait. Again we are going to deal with an older person, an elderly fisherman whom I met on one of my outings. This veteran, who was mooring his boat, was pleased to pose for one of my watercolors. I should add that, as a model, our fisherman is very interesting—his hair and mustache, which are perfectly white, the size of his powerful head, and his weathered face lined with deep wrinkles, all of which are highlighted by the oval shape of his beret. The figure appears in a three-quarter position, and I have included his strong hands in the composition.

MATERIALS

- Rough watercolor paper, 18" x 22" (46 × 55 cm)
- Soft pencil (2B)
- Round ox hair brushes (4-10)
- Flat brush of synthetic fiber, ¾" (2 cm)
- Tube colors: yellow ochre, burnt sienna, alizarin crimson, burnt umber, permanent green, sap green, cadmium red medium, and ultramarine blue.
- Palette with wells for holding the colors
- Old towel and absorbent paper

The background of the composition is painted with a very wet wash of burnt sienna neutralized with blue and yellow ochre. There is no need here for details or intense colors, for this warm gray is enough to create the effect of depth.

The green of the vegetation in the middle ground are washes of permanent green and sap green that are darkened with touches of blue in the lower part. Beneath the bushes, the ground is the same color as the background, although it is a more homogenous tone.

The fisherman's shirt is a very intense blue. This dark value added to the shadows cast by the man's body appears almost black, although the ultramarine blue can still be seen.

The hands of the figure have required a lot of work. The shape of the hands, the shadows on each finger, and the wrinkles, not to mention the detailed drawing itself, all require my attention. I work with orange, burnt sienna, and umber.

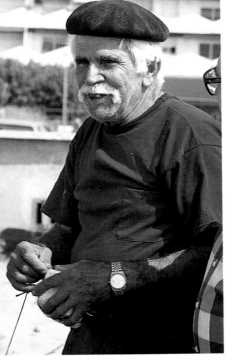

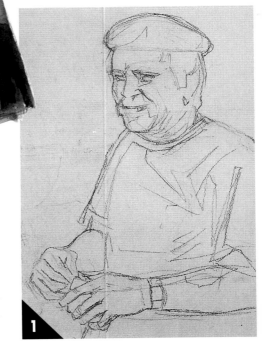

1 Here you can see several earlier studies and a first drawing of the watercolor, in which I work out the composition and the chromatic harmony. In this rather detailed initial drawing, you can see the composition I finally selected.

2 Since this is a portrait, it is important to capture a likeness in the initial drawing. For this reason, the drawing is much more detailed than in other watercolor paintings.

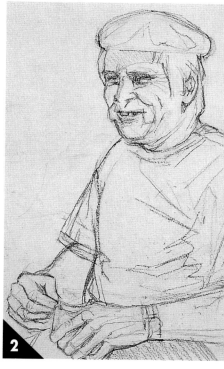

The painting of the face is as detailed as the hands, or perhaps even more detailed. The play of light and dark here is far more intense than in the hands and arms. Touches of color, like the red of the cheeks, add interest to the neutral sienna and umber flesh tones, as well as solidity and volume.

The highlighted folds of the shirt have been introduced by lifting color from the damp wash, working with a clean, wet brush. This lifting technique cannot remove all the color, so the paper is never completely white again.

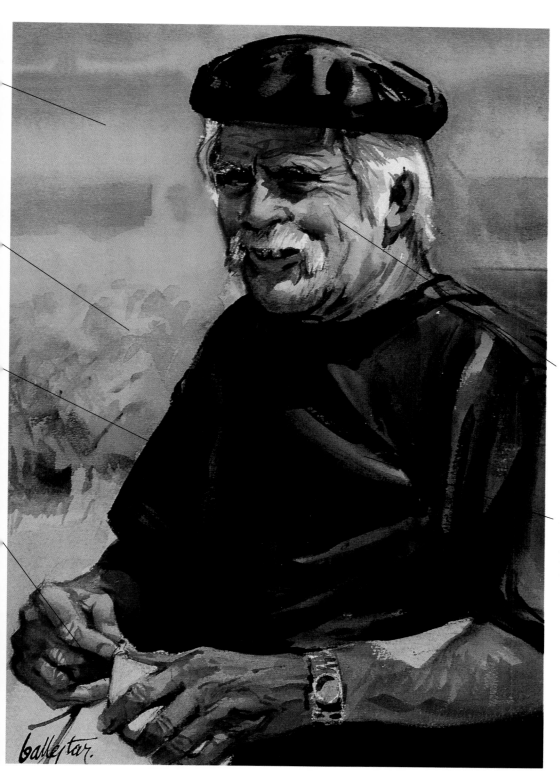

3 I begin to paint the head, working on the shadow cast over the forehead by the beret. I use a mixture of burnt sienna and burnt umber for a warm dark value that establishes the color harmony.

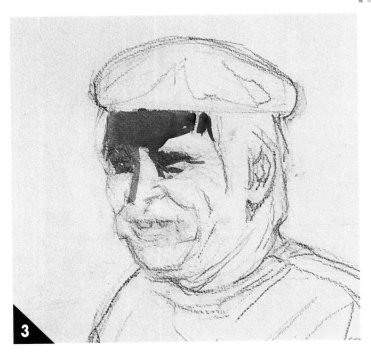

4 I continue working on the seaman's face using the same color in other areas. This mixture is very wet; thus it enables me to develop chiaroscuro with light and dark values.

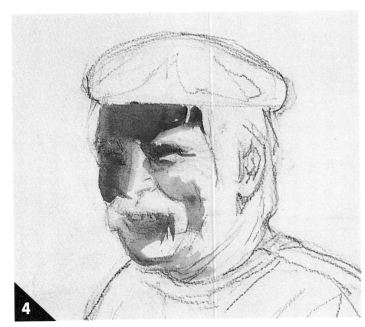

5 The entire face is now painted, leaving only the mustache and hair still white. The wrinkles near the eyes are also left white; I will work on them one by one.

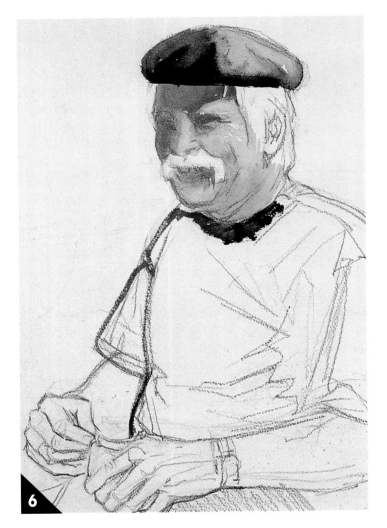

6 This is the first stage of the figure. The head and beret have been painted with grayish blue and burnt sienna, creating dramatic light and shadow.

7 Note how I have altered some of the facial tones, specifically the area under the cheeks and chin. I dampen the work and neutralize or gray down the color with raw umber to suggest the form and volume.

8 The shadow on the forehead is darkened somewhat in order to emphasize the lighted flesh tones. In addition, I have darkened the shadows of the beret, finishing the folds. The large shadow behind the head makes the white hair stand out.

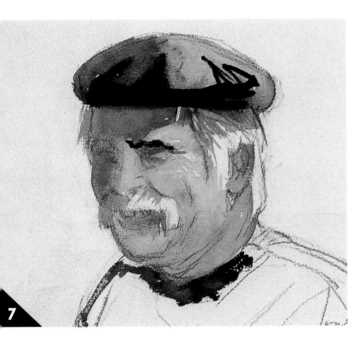

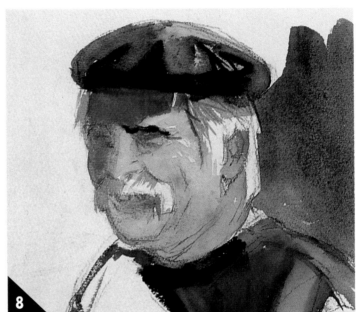

9 Most of the background has been painted now. I have begun to work out the correct values of the colors of the figure so they will contrast with the warm gray background.

10 Here we can see how the figure contrasts with the background color. Now I add a series of green washes on the background color to represent the trees in the middle ground. These trees establish the horizon line of the composition.

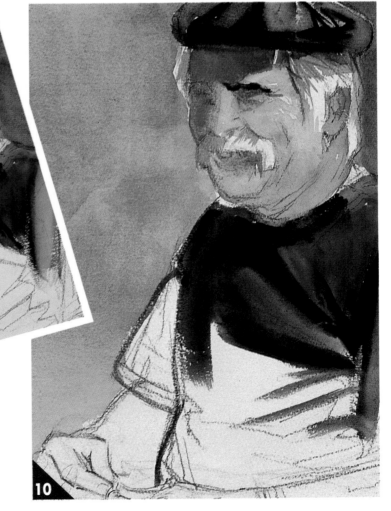

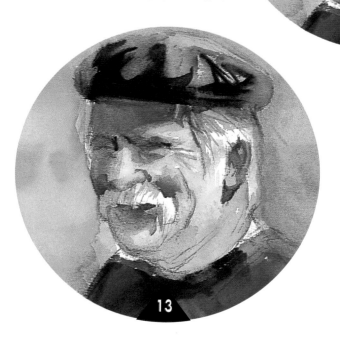

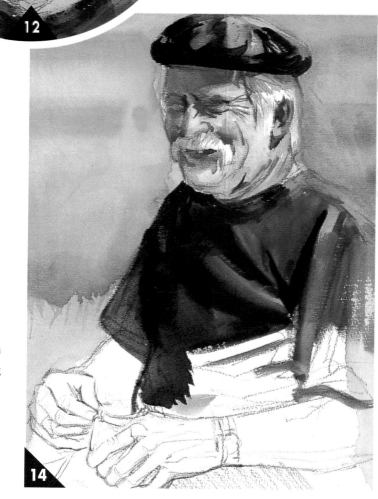

11 The folds of the fisherman's shirt create a rather interesting effect, as they add a sense of depth. The dark color alternates with strokes of pure ultramarine blue. This is a perfect color for giving expression to the face and for creating contrast.

12 The work on the beret produces a similar effect to that of the shirt; the depth of the folds is suggested by using a very dark color that is much grayer than the color of the shirt. This color gives us a wash of cool tones that heighten the warmth of the facial flesh tones. There is a transition in value from this dark beret to the shadows on the forehead.

13 The color and value of the face have now been worked out. I have gone over the deep wrinkles, using more intense color. I feel that the face is now ready.

14 The work on the arms and hands remains to be done. As you can see, I have been working from top to bottom, leaving the hands until last.

15 I extended the intense blue to the areas just below the left arm of the figure. I have also painted the fisherman's right forearm with alizarin crimson in a soft wash in the same value as the shadow, which is a transition between the dark colors of the shirt and the light values of the arms.

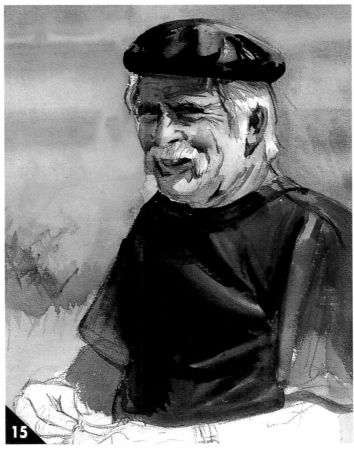

16 Here you can see the form and colors of the finished shirt. Even though I have worked on one part at a time, the final result appears to be a unified painting. This uniformity is due to the care with which I have followed the initial drawing.

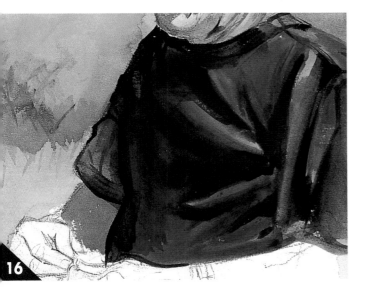

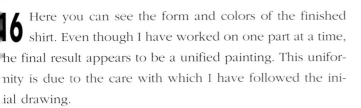

THE TEXTURE OF THE PAPER

The weight and texture of the paper play an important role in the final result of a watercolor. Weight depends on the size of your work. For large works, a heavy paper is more durable; whereas a lighter weight paper may be a good choice for small watercolors. Texture, or surface, depends on the number of details to be included in the painting. For a painting with many small details, hot-pressed (smooth) or cold-pressed (medium texture) would be better than rough paper.

17 I paint the arms with a rather dark wash of burnt sienna, leaving a small area on the upper part where the light falls on the arm. For this light area, I mix alizarin crimson and burnt sienna.

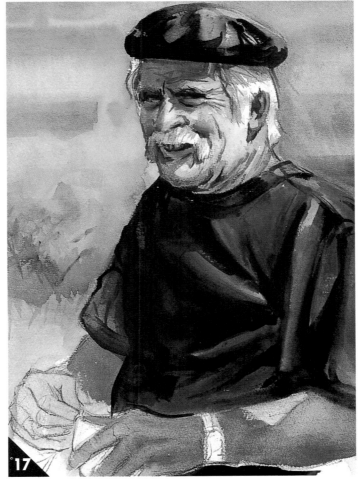

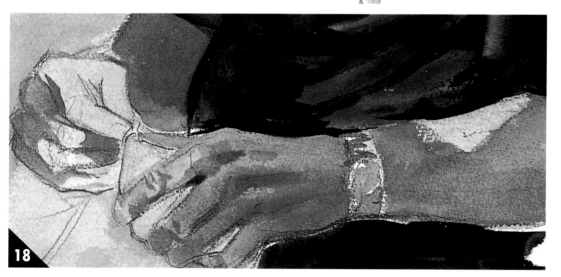

DRY COLORS

Dry watercolor in pans, if they are of high quality, are made to last a long time. If you haven't used a particular color in some time, all you need to do is to rub a wet brush over the surface of the paint and it will immediately come to life in all its splendor. For this reason, when you buy dry pans of watercolor, it is recommended that you spend a little more to acquire good quality paint.

18 Little by little, I model the arms, working on nuances of value and color. I also focus on the structure of the anatomy, intensifying the color in the darkest areas. This is slow work that requires close attention and care to achieve subtle changes of hue and value.

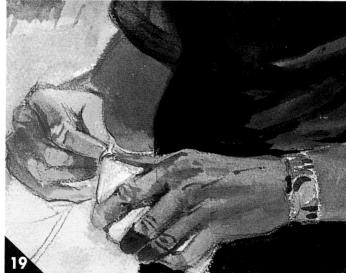

19 The play of light and shadow on the hands is the most complex aspect of this portrait. The pale, transparent colors are contrasted with darker values of intense color.

20 The watercolor is almost completed. I don't think it needs much more work except, perhaps, to tone down a certain hue or shadow that is too intense, or to accentuate some aspect of the hands. I do not want to lose the fresh quality of the watercolor.

21 The painting is now finished and you can judge the result. In my opinion, it is good both as a portrait and as a watercolor, as a result of the esthetic balance of form and color. I hope it will tempt you to try your hand at a portrait.

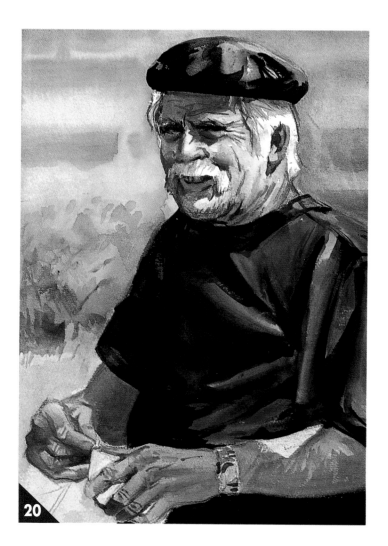

PORTRAIT OF AN ELDERLY FISHERMAN

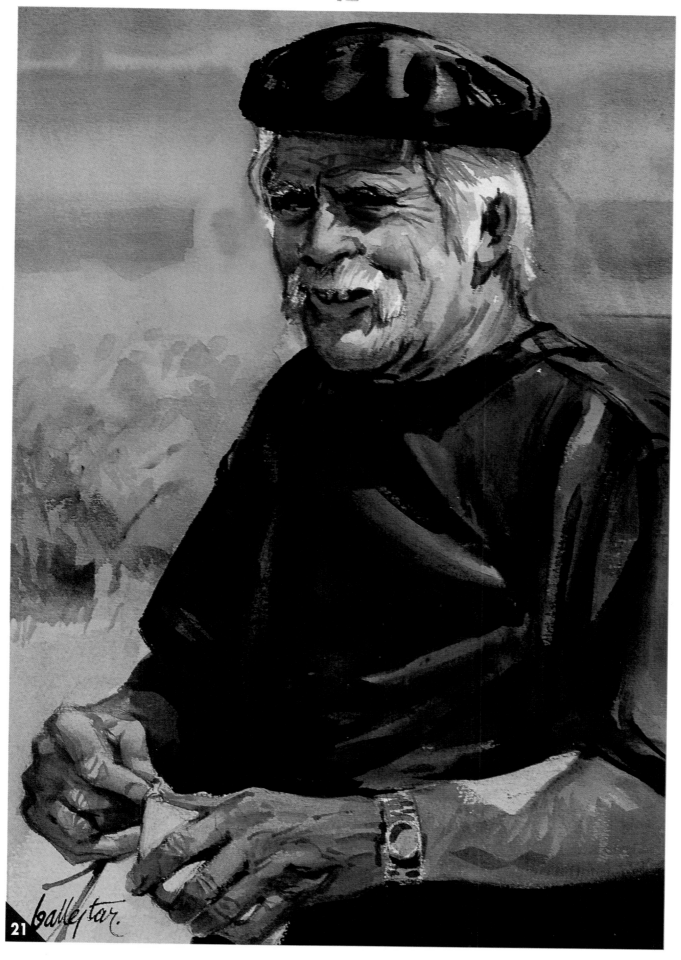

A FEMALE NUDE IN REPOSE

*T*his is a classic figure painting exercise: a female nude in repose, with some drapery. What is not so traditional here is the point of view I have chosen. The figure is upside down and is seen from above. In this way the plane of the bed appears almost parallel with the plane of the paper, leaving the spatial depth diminished. The pose is difficult to draw. The foreshortening of the legs will need to be drawn with the utmost care so that they do not appear deformed.

MATERIALS

- Rough watercolor paper, 18" × 22" (46 × 55 cm)
- Soft pencil (2B)
- Round ox hair brushes (4-10)
- Flat brush of synthetic fiber, ¾" (2 cm)
- Tube colors: cadmium yellow medium, yellow ochre, burnt sienna, cadmium red medium, alizarin crimson, burnt umber, sap green, and raw umber.

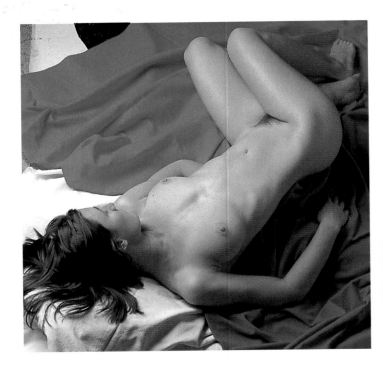

1 I draw a very detailed study. As I mentioned before, the drawing requires careful attention to anatomy, especially in area of the hip. Notice how the trunk flows into the buttocks and curves around to the thighs, all seen in foreshortening.

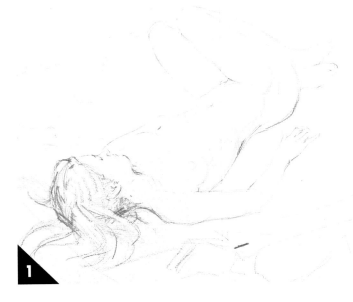

1

2 I first paint a flat wash of very dilute yellow ochre that I apply along the side of the figure in shadow. This color has to be painted wet-on-wet, so I dampen the paper beforehand to avoid breaks in the color.

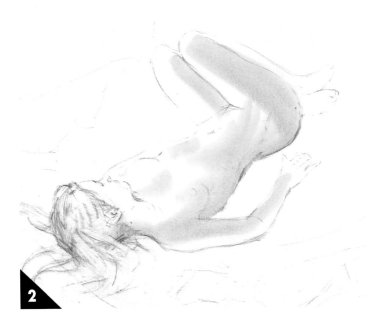

2

This dark gray-violet is a mixture of blue, alizarin crimson, and burnt sienna. The blue predominates and the color is very intense. The effect is that of velvet.

The red of the drapery on which the model rests is a cadmium red medium darkened in the shadows with alizarin crimson.

The thighs have been painted like two cylinders or columns. Their execution is simple—merely two strokes of the brush loaded with very diluted burnt sienna.

The feet and in general all the other dark parts of the figure have been painted with burnt umber. For shadows of medium intensity, I have mixed burnt umber with blue.

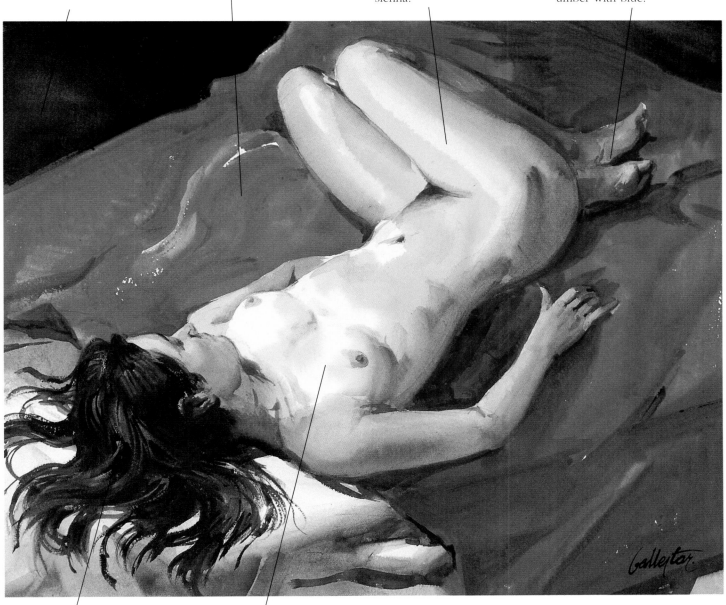

The hair is a rather rich color. Burnt sienna predominates but there is also some blue and alizarin crimson. Drawing with the tip of the brush is an excellent way to paint the waves of hair spread across the pillow.

The highlighted parts of the body are the white of the paper. I paint the transition from darker flesh tones to this white by gradually adding water to lighten the color until the color is nearly transparent.

3 Using the same yellow ochre as before, in a more intense hue, I paint the side of the face in shadow while continuing to work wet-on-wet. I use a round number 4 brush to shade the details of the eyes and nose.

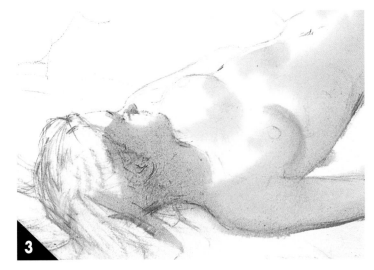

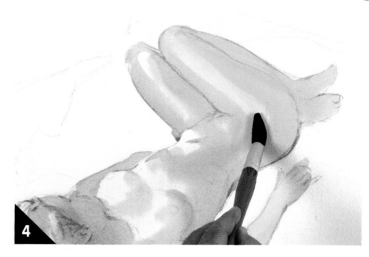

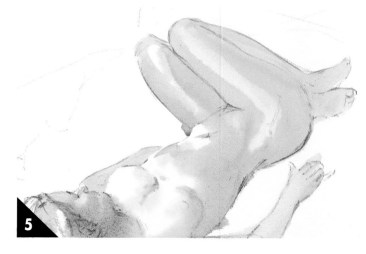

4 I work very rapidly during the initial phases of this picture. You cannot afford to waste time when working wet-on-wet or the blending effect is lost. I continue extending the color, adding more water to lighten the body where the light falls on it.

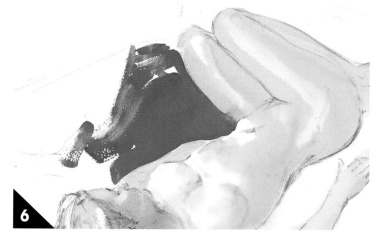

5 The figure is completely modeled with the color worked wet-on-wet. The rounded form has been painted very softly and, rather than darkening the shadows, I have lightened the highlighted areas until they are close to the value of the white paper.

6 I now use a flat brush to paint around the outline of the figure with cadmium red medium after the color is entirely dry. It is important to make sure of this, or the color may spread over the limits and ruin the flesh tones.

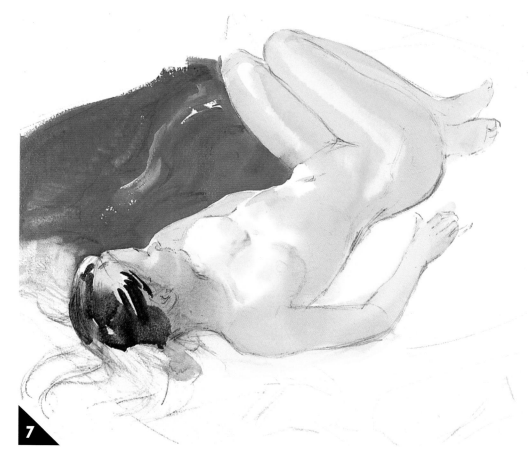

7 As I increase the size of the red wash, the chromatic effect of the watercolor becomes rich and beautiful. I now begin painting the hair with a very thin wash of raw umber on the lighted part of the head. This is intended only as a guide

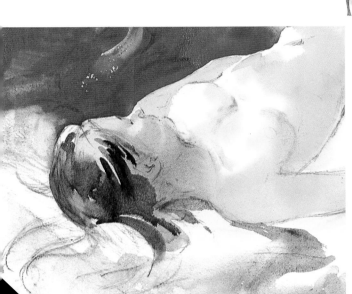

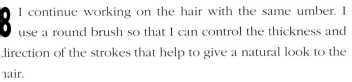

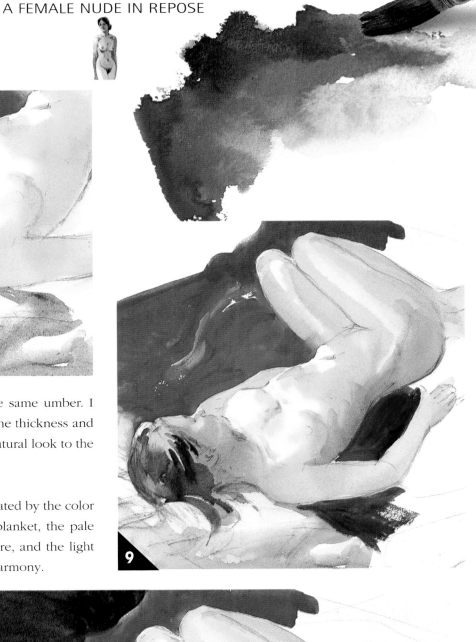

8 I continue working on the hair with the same umber. I use a round brush so that I can control the thickness and direction of the strokes that help to give a natural look to the hair.

9 In this closeup, we can see the effect created by the color harmonization. The intense red of the blanket, the pale flesh tones of burnt sienna and yellow ochre, and the light gray of the pillow create a rather elegant harmony.

ALTERNATING BRUSHES

Most watercolors call for a variety of painting techniques; therefore, I alternate between using flat or round brushes, depending on what I have to paint. Flat brushes are preferable for painting large areas, while round brushes, which taper to a point, are better for painting lines and details.

10 On the right, below the arm, you can see how the mixture of alizarin crimson and cadmium red has a darkening effect. Alizarin crimson always lends tones depth and creates a slightly velvety texture.

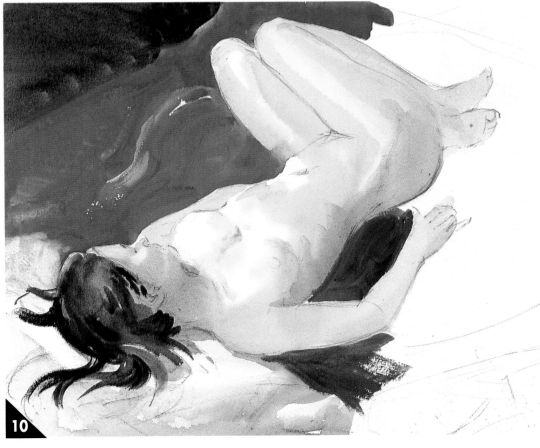

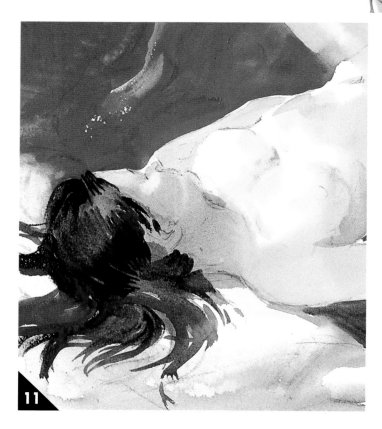

11 Notice the light touches of shadow that can be seen on the neck, around the breasts, and down one side, in the area of the ribs. They are touches of very diluted blue that cool the tone down and help to give a feeling of volume to the body.

12 Here we can study the way in which I treat the hair. I work with the round brush using a range of earth colors, burnt sienna, raw umber, and burnt umber, superimposing brushstrokes that follow the direction of the hairstyle.

13 The paper is almost completely painted. As I mentioned earlier, the basic color harmony has already been established so I won't be modifying or changing the values too much from now on. There is still some modeling to do, although care has to be taken not to spoil the quality of the flesh tones, which look somewhat like ivory. I want to preserve this delicate treatment of the skin, even though I have to darken several areas to prevent the figure from appearing "glued" to the red blanket.

14 Here you can see the way in which I gradually darken the body with great care. I deepen the shadows by using a dilute wash of burnt sienna. This can best be seen in the dark shadows on the legs.

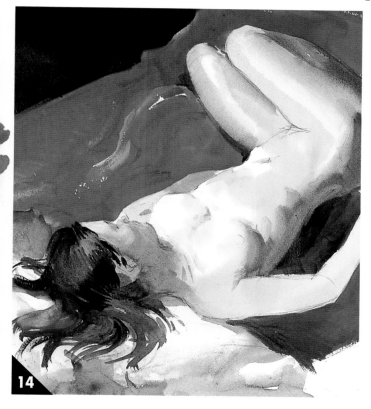

15 I continue intensifying the shadows on either side of the figure, using burnt sienna mixed with a little blue. These colors are thinned down with enough water to mix a middle value of a neutral gray.

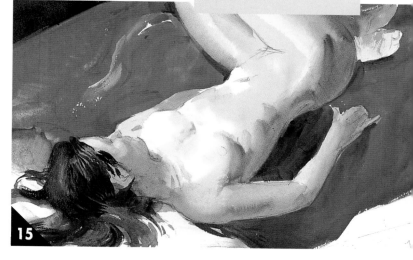

16 The only work remaining on the figure involves the feet, the hand, and the stomach. The hair is finished by adding several strokes to give it greater solidity. The foreground has still not been painted, but the general appearance of the watercolor is established so that I will not make any major changes.

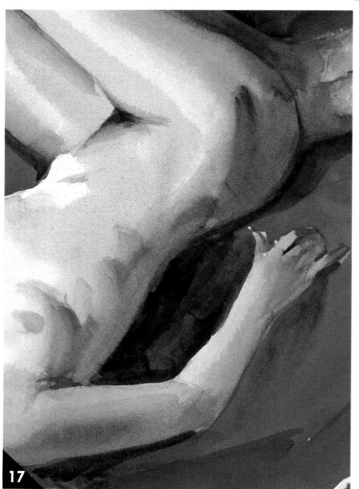

17 In this detail you can see the finished painting of the hand. The hand is a small but important detail because, being separated from the rest of the body, it immediately attracts the viewer's attention.

18 Almost the entire paper has been painted, but there is an area at the bottom that still needs to be filled in. I take advantage of this to create a fold, which is easily done with some strokes in a darker value of the red wash. The watercolor is almost finished and now I only need to work on the details.

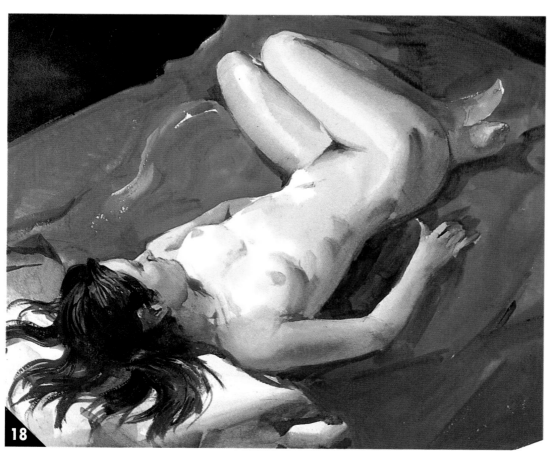

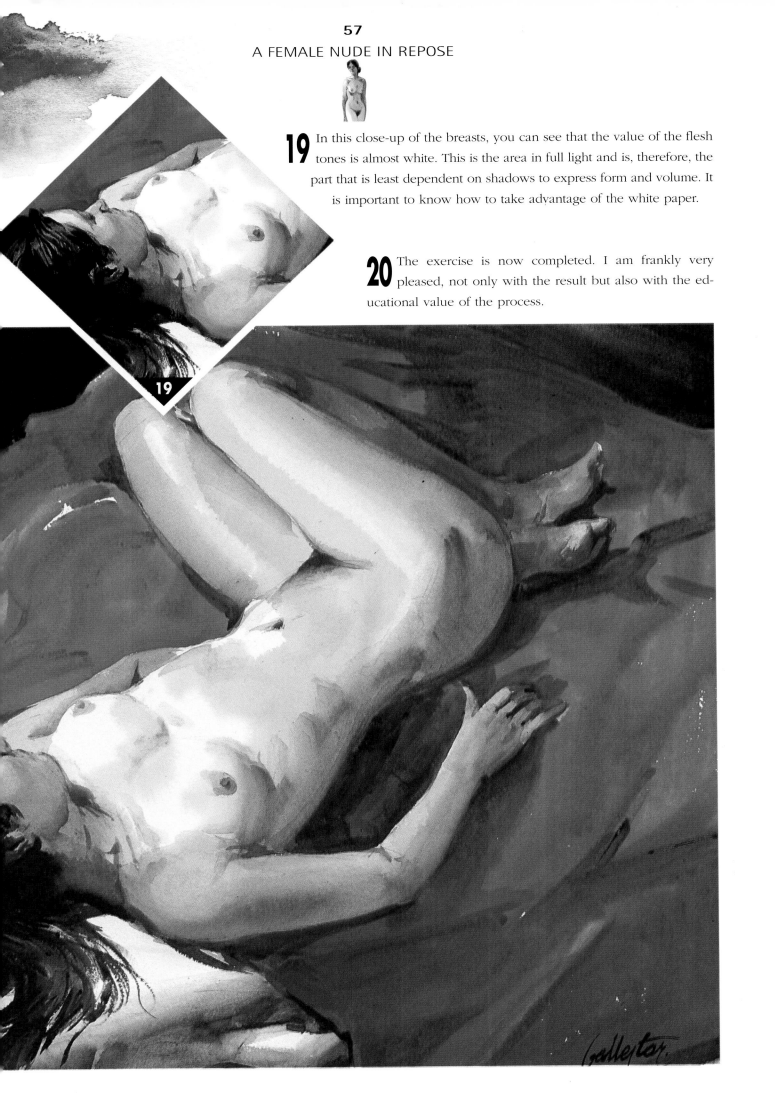

19 In this close-up of the breasts, you can see that the value of the flesh tones is almost white. This is the area in full light and is, therefore, the part that is least dependent on shadows to express form and volume. It is important to know how to take advantage of the white paper.

20 The exercise is now completed. I am frankly very pleased, not only with the result but also with the educational value of the process.

THE FEMALE FIGURE IN PROFILE

For the last exercise in this book, I have chosen to paint a figure in repose, in profile. This horizontal composition is reinforced by the line that crosses the scene in the top part. In cases like these, the painting of a figure is more akin to the painting of a landscape and, although the technique and spirit of the genre may be very different, it is possible to think of the female body as a kind of landscape created by the surrounding folds and drapery.

MATERIALS

- Rough watercolor paper, 18" × 22" (46 × 55 cm)
- Soft pencil (2B)
- Round ox hair brushes (4-10)
- Flat brush of synthetic fiber, ¾" (2 cm)
- Tube colors: cadmium yellow lemon, burnt sienna, raw umber, alizarin crimson, burnt umber, cadmium red, ultramarine, cobalt blue, and sap green

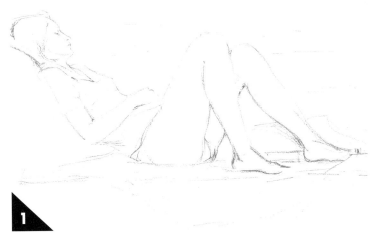

1 This pose does not require a detailed initial drawing as the other exercises did. In fact, sketching this pose is rather easy and depends entirely on knowing how to correctly capture the line of the legs and the trunk, as well as the placement of the feet and buttocks on this raised plane.

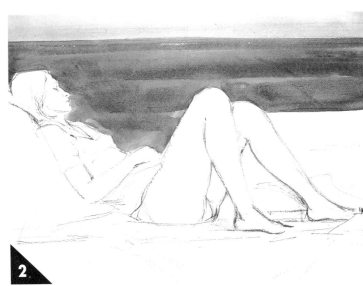

2 I begin to paint the wooden panels that form the horizontal line that traverses the room, using sweeping brushstrokes of very wet burnt sienna. I use different intensities of the color to show the form and the joints between the panels. I leave the figure unpainted while I carry out this work.

The face of the figure has not been worked on although it stands out clearly against the dark composition. I have darkened the background to balance the light value of the face.

The wooden panels are not of a uniform tonal intensity. This area is darkened by the shadow cast by the figure and is treated with such a saturated color that it appears almost black.

The stockings that the model is wearing are painted with unmixed raw umber. They are painted like cylindrical forms using washes of different values.

The light falling on the sheet clearly indicates the plane on which the figure reclines. This light and plane are painted with a very watered-down color.

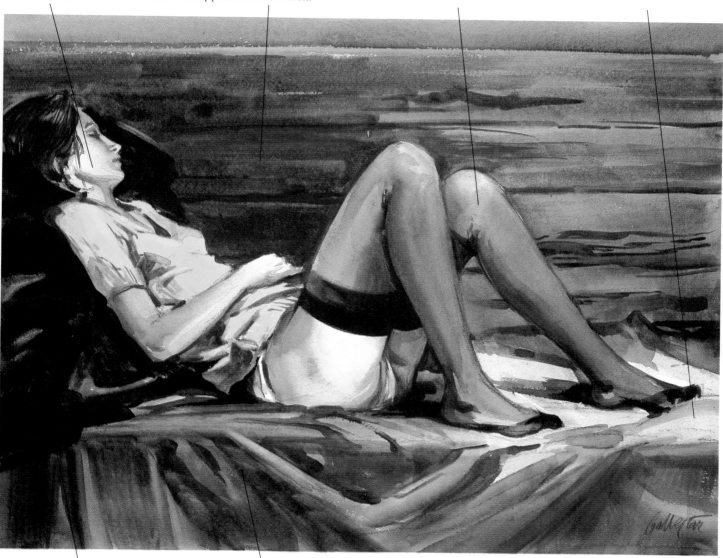

This is the darkest area of the composition, the part where the shape and details become lost in the shadows. This color is an intense blue, tending toward violet due to the addition of alizarin crimson to the mixture.

The sheet is painted in a neutralized blue, grayed in the lightest areas and more violet in the darker ones. I emphasize the three-dimensional aspect of the larger creases and folds, but with the smaller ones I merely suggest the creases with rapid strokes of the brush.

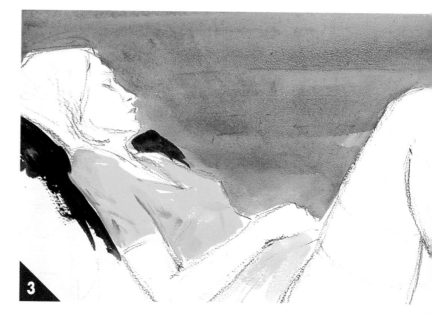

3 This is the most dynamic contrast in the composition, the dramatic color contrast between the lemon yellow of the blouse and the burnt sienna of the hair.

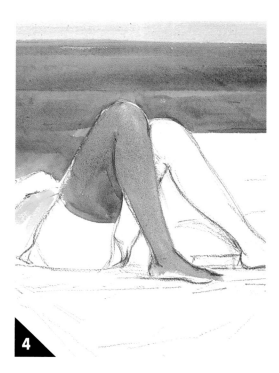

5 The stocking has been modeled with a clean, wet flat brush. I lift out part of the color down the center of the leg, to model the form and to suggest the typical transparent appearance of a stocking.

4 I paint one stocking with raw umber. This is done with a single stroke of the brush covering the entire area of the leg. I allow the color to accumulate in certain points, somewhat according to random chance, knowing that I can work on the form and volume later.

6 In this detail, you can see the strokes with which I indicate the creases of the pillow. I mix burnt sienna with the blues of the sheet in order to create a very dark value.

7 To this point I have concentrated on the essential contrasts—the blouse and the flesh against the background and also against the colors of the sheets.

WETTING THE PAPER

If you are painting a watercolor in a hot, dry climate, it may be helpful to wet the paper. This will prevent the initial washes from drying too quickly, which can cause harsh breaks in the color. If you paint a watercolor in winter, or during a cool spell, it is better to simply dampen certain areas of the paper because it dries much more slowly.

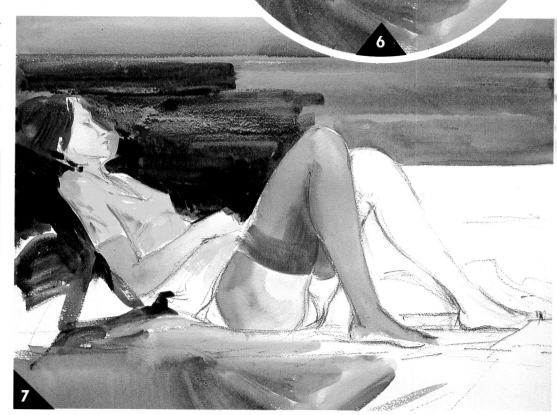

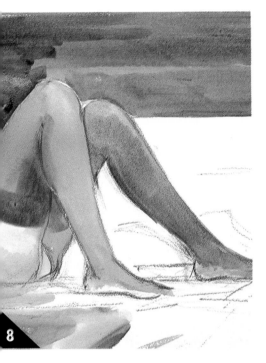

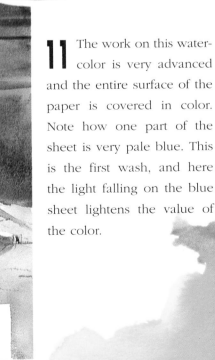

9 In this detail, you can see the shadows of the creases of the yellow blouse. This work is done by applying a very soft wash of raw umber over the dry yellow wash. It is essential that the color be dry in order to avoid one color running into another, which can spoil the pure color and make it muddy.

8 This is the area that is still left to be painted. The second leg has now been painted using the same process that was used with the first one—applying a wash of color and going over it with a clean brush to lift out some of the color. By lightening the value of the central area, the form is emphasized.

10 I am trying to make the dark value of the yellow blouse consistent with the dark values of the pillow. This I do with blue, creating greens that darken certain areas of the blouse.

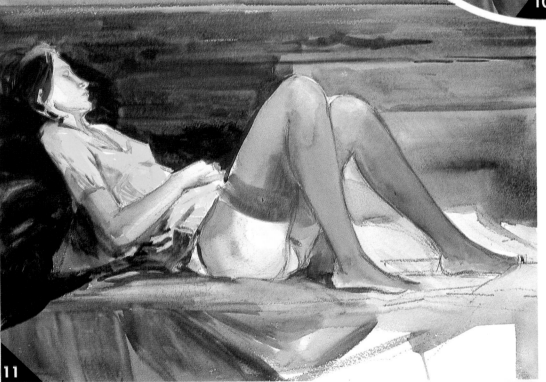

11 The work on this watercolor is very advanced and the entire surface of the paper is covered in color. Note how one part of the sheet is very pale blue. This is the first wash, and here the light falling on the blue sheet lightens the value of the color.

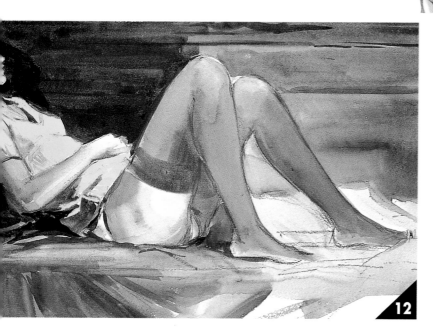

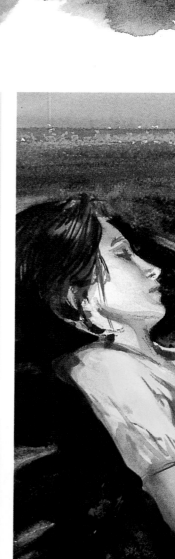

12 Note how grooves can be seen between the wooden panels. They have been resolved by drawing a dark line with the tip of the brush, then lightening the top part of the line to create the effect of a joint.

TAKING CARE OF YOUR BRUSHES

It is relatively easy to take care of your brushes: Clean them in water; then wring them out and allow the hairs to slide against your fingers without pressing too hard on them. Once you are sure there is no remaining paint in them, place them upside down in a box.

13 The watercolor is almost finished and in these final stages I work on the buttocks and the rest of the figure that is in contact with the sheets, refining shadows and darkening some values.

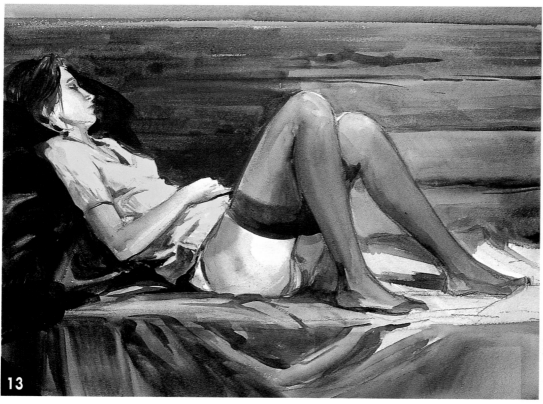

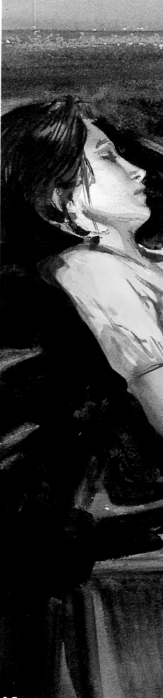

14

14 I darken the base of the feet to create the impression that they are firmly planted on the sheet. Notice here that the treatment of the creases has been based on transparent washes and short, decisive brushstrokes.

15 This is the final result of this last exercise. I believe that the contrast of light and color creates a dramatic effect, both visually and psychologically, which is inevitable when one is painting figures.

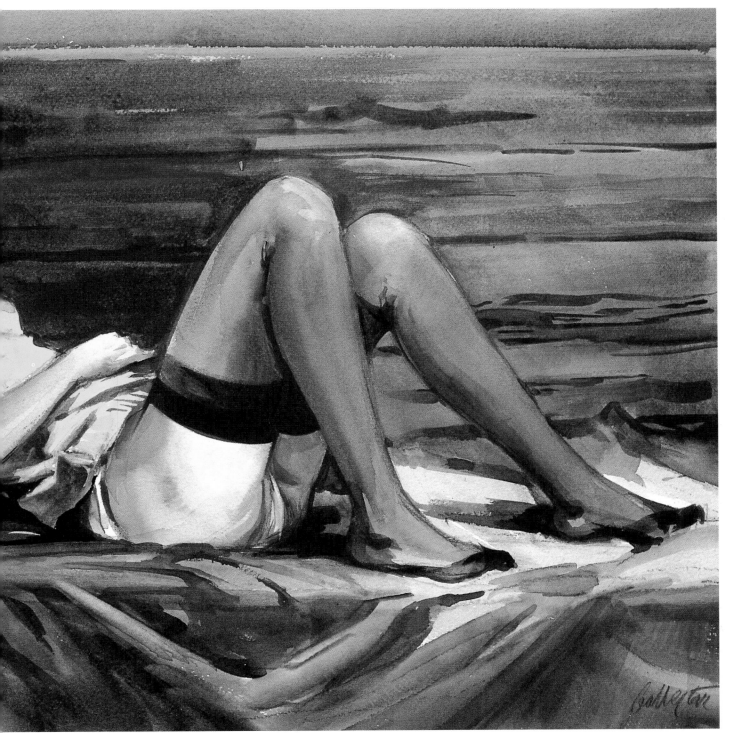

ACKNOWLEDGMENTS

I would like to express my thanks to the following people without whom this book would not have been possible.

To Jordi Vigué, without whose encouragement and invaluable advice this project would have never have gotten off the ground.

To David Sanmiguel, for his collaboration and assistance at every step of the editing process.

To the Nos y Soto Studio, which supplied all the fine photography.

To all the models who posed for the paintings, my thanks for their patience and understanding.

To Josep Guasch, for his extraordinary book design.

To Jordi Martínez and Carlos Escobar for their work on the layout.

To the Casa Piera, of Barcelona, for supplying all the drawing and pastel materials.

Thanks to everyone.

Vicenç B. Ballestar